A RENAISSANCE LIKENESS

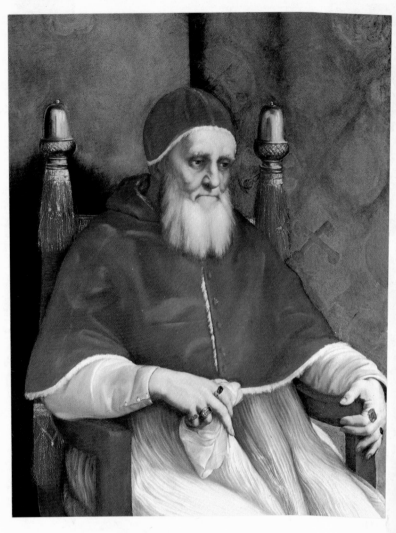

Raphael, *Portrait of Pope Julius II*, 1511–12.
London, National Gallery.

Loren Partridge
and Randolph Starn

A Renaissance Likeness

ART AND CULTURE IN
RAPHAEL'S *JULIUS II*

University of California Press
Berkeley · Los Angeles · London

LIBRARY OF CONGRESS CATALOGING IN PUBLICATION DATA

Partridge, Loren W.
 A Renaissance likeness.

 Bibliography: p.
 Includes index.
 1. Raphael, 1483–1520. Portrait of Pope
Julius II. I. Starn, Randolph, joint author.
II. Title.
ND623.R2P26 759.5 79–63549
ISBN 0-520-03901-7

University of California Press
Berkeley and Los Angeles, California

University of California Press, Ltd.
London, England

© 1980 by
The Regents of the University of California

1 2 3 4 5 6 7 8 9

For Orin,
 Drina,
 Wendy,
 and
 Amy —
 sharp seers.

Contents

Illustrations

PLATES
(following page 159)

Preface

This book is at once sharply focused and wide-angled. It is an analysis of Raphael's *Portrait of Pope Julius II* in the National Gallery at London and a case study in the content and context of High Renaissance portraiture. It is also an essay in cultural history broadly defined, for like the microcosms Renaissance writers discerned in very particular things, Raphael's *Julius* opens whole worlds worth exploring.

Raphael's portrait is full of messages from Renaissance culture in part because the circumstances in which it was made were so full. At the earliest date —27 June 1511—when the painter could have begun his work, Pope Julius had ruled eight years at his furious pace, "the eighth wonder of the world," a Renaissance pope in all his roles but always in his own way. Contemporaries had already found it easy to speak of a new Golden Age or to fear the coming of the Apocalypse. During the nine-month period in which the London panel was apparently painted, the character of the pope and the culture of Julian Rome were being tested more intensely than ever. Instead of triumphs everywhere, now there were challenges on every side. In northern Italy papal territory only recently regained by Julius himself had been lost to the French. A council of schismatic cardinals was

meeting at Pisa. The pope was struck by a nearly fatal illness, and Rome flew into revolt. The resources of the papacy were strained to the breaking point. By March 1512 the situation was still in some doubt, still near the beginning of what was to seem a miraculous series of victories before Julius's death in February 1513.

The time had been right for taking a full measure of the man and the pope. But the London portrait also coincided with Raphael's arrival at new heights of achievement in the company of an extraordinary group of artists working in a High Renaissance style. A brief, classical moment held visions empirical and ideal in balance. The great Julian projects were under way. Some commissions were complete, or nearly so, and all were to be new classics in their own right—Bramante's Belvedere and St. Peter's; Michelangelo's Sistine Ceiling and tomb for Julius; Raphael's own fresco cycles for the papal apartments in the Vatican palace, the *Stanza della Segnatura* and the *Stanza d'Eliodoro*. The Julian additions to the church of Santa Maria del Popolo seem relatively minor only in comparison with the overwhelming scale of what was happening elsewhere in Rome. By September 1513, and probably during Julius's lifetime, the panel now in the National Gallery had entered the church which had long been a favorite sanctuary and Roman showplace of the pope and his Della Rovere relations.

No Renaissance figure had inspired (or provoked) a more vivid response than the *papa terribile*. There were other painted portraits of the pope besides the London likeness, at least five of them by Raphael

himself. Medals, coins, drawings, woodcuts, and sculpture also displayed the papal image. Vignettes in words appeared in chronicles, histories, memoirs, literary works, sermons, and letters. We even have the perspective from the diaries of a papal master of ceremonies, and to counteract the flattery of courtiers and would-be clients we have the antidote of critical tracts and satire. One of a kind, Raphael's picture should be seen in light of this rich and many-sided record of the Julian Age.

This is not the usual view. The relevant volume of Ludwig von Pastor's monumental *History of the Popes* is still a valuable mine of information, but it is also fragmented in form and apologetic in tone. From more recent historians we must make do with more or less casual profiles, passing references, and a few specialized monographs. From the art historians, who could hardly be expected to slight one of the great moments in the history of art, there is no shortage of very good work on individual artists or commissions in Julian Rome. What is usually lacking is a thoroughgoing concern for the historical setting and the interrelationships of form, content, and style. The only recent writing on Raphael's *Julius,* for example, is brief and mainly devoted to the art historical detective work which established some ten years ago that the National Gallery panel, among several extant versions, was Raphael's original. It is as if the Julian world were too vast for the far-reaching kind of inquiry it deserves. Perhaps only the range of scholarly specialization has become too small.

It is a welcome sign, though not always a very

carefully articulated one, that some current attempts to see art in context take wide-ranging views of culture. The best of these are more likely to speak of complicated circumstances than of single causes. They have made issues of the cultural themes and cognitive skills peculiar to different times and places, the patronage and commissioning of culture, and the particular functions of art. Individual works have been reconsidered, as art certainly, but also as artifacts. In this spirit we mean to cross and combine different kinds of evidence and lines of approach, keeping Raphael's *Julius* in sight, but moving from it to the concerns of the culture around it, and back again. By varying the levels of analysis we hope to avoid the narrowness of purely formal, iconographical, or "sociological" explanations, and to confront something of the sheer complexity of whatever men have made. By concentrating on a single object we hope to respect the integrity of the work of art, to resist losing it either in the high abstraction of a prescriptive period style or in historical detail.

In the newly restored radiance of Raphael's portrait masterpiece both art and culture shine through.

However small, this book has accumulated large debts. Its origins go back at least to Harvard, to Myron Gilmore and to Sydney Freedberg, Master of Seeing. It owes much to the patience of our Berkeley undergraduates, who have often had good reason to wonder whether two heads, historian's and art historian's, were better than one. To the "Julian Institute" of our joint graduate seminar special thanks, in par-

ticular to Priscilla Albright, Carroll Brentano, Mark Fissel, Barbara Wollesen-Wisch, Brian Horrigan, Christy Junkerman, Elliott Kai-Kee, Gregory Lubkin, Frederick McGinness, Lorean De Pontee, and Keith Thoreen. Elliott Kai-Kee contributed extra time and expertise in research, and Patricia Fortini Meyer had much to show us about the church of Santa Maria del Popolo, of which she has done the drawings for this volume. Dorothy Shannon has typed it all with her generous care. The Committee on Research and the Humanities Institute at Berkeley have given their support. For the efforts of so many our sense of *magna in parvo* is complete.

1
Raphael's Julius *and Renaissance Individualism*

The earliest responses to Raphael's portrait of
Julius II took it to be natural and lifelike. Vetor
Lippomano had observed the *papa terribile* at dan-
gerously close quarters during his years as Vene-
tian ambassador in Rome, and when the portrait was
displayed on the altar of Santa Maria del Popolo
early in September 1513, he found it "very similar to
nature." The pope had been dead since the second of
February, but, reported Lippomano, "all Rome" had
crowded to see "him" again, as if for a jubilee. We
can only guess at the reactions of the anonymous
writer of the 1540s who limited himself to mention-
ing that the *Julius* and Raphael's *Madonna of the Veil*
were hung for feast days on pillars in the church of
the Popolo (Plates 1–3). But for Giorgio Vasari in
the 1550 edition of his *Lives of the Most Eminent
Painters, Sculptors, and Architects* the portrait seemed
still "so wonderfully lifelike and true that it inspired
fear as if it were alive."

Although Vasari often saw only what he thought
fitting to see, there is, for once, no reason to doubt
him. His reaction was the conventional one, inspired
by classical writing on art; and yet it *is* the illusion of

nature, the sense of a powerful individual presence portrayed in a moment of time, which confronts us first and foremost in Raphael's *Julius*. The figure of the pope appears nearly lifesize, not encased forbiddingly in full pontifical regalia but dressed in the less formal *camauro* and *mozzetta*—the short, hooded cape and the cap, red velvet and ermine-trimmed— of his everyday appearances. Seated at an oblique angle and projected in three-quarter length toward the surface and edge of the panel, he seems to occupy the corner of a room. As if to make this angle of space more approachable, Raphael, as we know from X-ray analysis, painted out the papal tiara-and-keys which had originally figured on the green background cloth. There is little of the purely emblematic, official profile here and even less of the relentless hieratic display of the later, full-length state portrait. The hardening of the image into the model of a conventional portrait type was the work of its imitators. What strikes us immediately in the original is the animated repose of an individual, the rich topography of the face, the believable anatomy, the firm composition enlivened by the play of color, texture, and detail.

The likeness is individualized from its surfaces— literally from the tip of the beard—to the character they seem at once to express and enclose. More than any other feature, the beard fixed and dated the unique physical presence of Pope Julius in the eyes of his contemporaries. One of his favorite preachers, the Augustinian Giles of Viterbo, exaggerated (as

usual) in claiming that Julius was the first pope "for
centuries" to wear a beard. French popes at Avignon
had been bearded until the mid-fourteenth century,
but the spectacle of Julius's beard cut memories
short. With a hint of exasperation understandable in
a master of ceremonies at the Julian court, Paris
de'Grassis noted in his diary that the pope had first
begun to let his beard grow during his long illness at
Bologna after October 1510. Early in November of
the same year he was reported to have "a palm's
breadth of white beard," and a little over a month
later he appeared, fully bearded, in procession
through the streets of Bologna. Before March 1511
the news had reached Spain, where Peter Martyr
wrote about wits in the Roman court complaining
that "this bearded Peter, fisher of men, had ab-
sconded from Rome with the keys to Paradise."
When Julius returned to Rome on 27 June 1511 from
his campaigns in northern Italy, Roman observers
took in the sight for themselves—"no one remem-
bers anything like it," exclaimed one chronicler—
and they were not to see their bishop clean-shaven
again until early March 1512. By that time, presum-
ably during the intervening nearly nine months,
Raphael had certainly captured and had probably
completed the likenesses of the pope in the National
Gallery portrait and elsewhere.

Other physical details rendered in the portrait
seem to correspond to particular contemporary im-
pressions. Raphael's *Julius* presents an awesome old
man of about seventy—*il vecchione* of the diplomatic

correspondence and the chronicles. Nearly ten years
earlier Francesco Gonzaga had commented on the
"ruddy and robust" appearance of the new pontiff.
During the pope's triumphant stay at Bologna in
1507 a chronicler from Forlì had described "the
round face, all rosy," "the fine, big eyes," "the
short neck, like all his other members, well-pro-
portioned." For him the pope was "a man of aver-
age stature," who "paced with sweeping steps."
Some of the features described in those earlier and
better days are still evident in the London likeness.
But the illnesses and trials of 1510–12 have left
their mark. Raphael's subject no longer seems decid-
edly "erect in his person," as he had been at Bologna;
his age appears more invasive than "prosperous,"
and the flush hints as much at fever as high spirits.
Without violating decorum Raphael shows us the
Pope Julius whose erratic health and political mis-
fortunes during these years were being watched
with macabre fascination. The likeness is plausibly
that of a man reportedly afflicted by gout, infected
with syphilis, and prone to drunkenness; plausibly,
too, that of the pope whose earlier victories were
threatened by the loss of Bologna to the French, the
schismatic council of Pisa, and unrest in Rome itself.

But it would surely be wrong to see only the
characterization of a broken man. The driving ani-
mation of the pope and his inner reserves of resis-
tance press into the picture as they do into the
written record. The torso may be bent in the por-
trait, but it is powerful; the mouth is clamped as
much in determination as dejection, and the down-

cast eyes are fiery. Through the worst of times Venetian ambassadors saw the pope as "strong," as "above all others *fortissima.*" For Machiavelli, Julius remained "violent," "audacious," "unstable," "hasty," "rash." Other contemporaries agreed that the pope was "choleric." This quality was hardly exhausted by a raging tongue. "What is more, he pushes and punches someone, cuts at someone else . . . with so much choler that *nihil supra,*" wrote one witness of the famous siege Julius led in person against Mirandola in January 1511. These violent scenes—one thinks of psychoanalytical discussions of "primitive rage"—were interrupted by periods of brooding, of half-spoken soliloquies, of plans or reasons changed without warning. "The pope has a mind all his own, and its depths cannot be fathomed."

The Venetians, a Florentine ambassador, agents of the Gonzaga of Mantua, Julius's own master of ceremonies, and, eventually, the king of France concentrated the impact of the pope and the man into a single word. For all of them Pope Julius was *terribile.* This Julian *terribilità* was understood as a function of the pope's "terrible nature." It was associated, almost clinically, with the physical centers of his being—heart, brain, and soul. It was a brute, animal force. But *terribilità* also implied in Julius, as it was beginning to do in the artists he patronized, a consummate ability to master nearly insuperable obstacles. At these outer limits in the vocabulary of his contemporaries the power of Julius (or of Michaelangelo) was *deinotic,* a power of divin-

ity. In language used not by courtiers alone but also by tough-minded diplomats, Pope Julius, like a supreme deity, "makes all tremble," "fulminates," "without reason obtains whatever he wishes." Raphael's *Julius* might have served as an illustration. Our uncertainty over what to expect were the figure to rise connects us perhaps as closely as art can ever do with an individual presence in the past.

A portrait seemingly true to nature and to life, the sense of a powerful, unmistakably individual presence—contemporary testimony and our own first impressions converge. But this convergence brings us only to the beginning of a classic problem in Raphael's *Julius* and the culture in which it was made.

In what must be the most celebrated and the most controversial passage of *The Civilization of the Renaissance in Italy,* Jacob Burckhardt described a kind of individualism he considered Italian and Renaissance in origin. Renaissance Italians had pierced a medieval "veil . . . woven of faith, illusion and childish prepossession, through which the world and history were seen clad in strange hues." Where men had been conscious of themselves in the Middle Ages "only through some general category," in Renaissance Italy, claimed Burckhardt, "an objective treatment" of the world had merged with a subjective consciousness of self as "man became a spiritual individual, and recognized himself as such."

A whole history of subsequent views of the Renaissance might be written around reactions to these

lines by medievalists objecting to the timing, na-
tional historians (non-Italians at least) critical of
the location, and specialists who have hedged
Burckhardt in with qualifications. Medieval "veils,"
we have been reminded, were often transparent and
not easily lifted; Renaissance men had their share of
"childish prepossession" and often perceived them-
selves through general categories. But Burckhardt's
insight has shown little sign of going away. Even if
it did not "swarm with individuality," the culture of
the Italian Renaissance was driven by complex sets
of tensions between tradition and innovation, pat-
terns of integration and pressures for dispersion,
conventions of thought and feeling and a fresh
openness to experience. In such a culture the re-
sources of the individual could surface to be thrust
and measured against traditional expectations and
collective restraints. Perhaps no individual has ever
been the utterly free agent of Burckhardt's nine-
teenth-century imagination, but the concrete experi-
ence and the potential of the individual personality did
become one persistent dimension of a search for bear-
ings in Renaissance Italy.

It is consistent with this outlook that portraiture
became a major genre of Italian Renaissance art. But
this does not mean that the qualities of Renaissance
individualism are easy to define in any given in-
stance, still less that they are easy to account for. The
problem is complicated in the case of art by the
difficulty of translating visual experience into words.
The term *individualism* was coined in the nineteenth
century for nineteenth-century sensibilities. It tells us

nothing at all about formal qualities in works of art;
for that matter, it may be positively misleading for
directing our attention elsewhere. If individualism in
art was a good child of Renaissance culture, then it
really must be seen, not heard.

Contemporary reports and our own responses
have already helped us see, but we can bring Ra-
phael's *Julius* into sharper focus by examining the
visual relationship of the painting to motifs and
forms in portraiture which preceded it. By viewing a
particular papal portrait in the context of traditions
of papal portraiture, it should be possible to deter-
mine something about the extent of its particularity.
Renaissance traditions of independent secular por-
traiture supply another context for comparison and
for contrast. We can also locate the London panel in
the development of Raphael's own portrait style.
Where precedent proves to be lacking or where the
sources in art available to Raphael and his patron
were used in self-conscious inventive ways, there
at least Renaissance individualism can be given quite
precise visual meaning.

Two conventions of papal portraiture were espe-
cially important to the making of the London panel.
For more than half a century before 1511–12 popes
had been commonly represented as supplicating
donors, standing or kneeling in profile in the com-
pany of saints to offer good works in pious appeal
for salvation. Increases in scale and apparent veri-
similitude can be traced within this portrait type
through the Quattrocento: the kneeling figures of

Eugenius IV in Filarete's bronze doors for St. Peter's (c. 1440–45); Perugino's Sixtus IV in the lost *Assumption of the Virgin* for the Sistine Chapel altar (c. 1481–82); Pinturicchio's Alexander VI for the *Resurrection* of the Borgia Apartments in the Vatican Palace (c. 1492–94). Profile medals of fifteenth-century popes exhibited the same direction of development in a more restrictive medium. By the 1490s Pinturicchio could suggest Alexander VI's boundless personal ability and equally boundless self-indulgence in the intimate and almost embarrassingly frank profile he painted atop a stiff, jewel-encrusted cope of gold (Plate 4). In acuteness of observation and psychological penetration, then, Raphael continued precedents in papal portraiture which, at the same time, he surpassed in subtlety and concentration. The patron presumably approved or even insisted. It was not only in politics that Pope Julius was determined to outdo his predecessors, above all his Borgia rival Alexander VI.

The disposition of the figure on a chair or throne gathered up, without being strictly limited to, variations on another papal portrait type. With an ancestry extending back to imperial Rome, seated statues of the pope were customarily placed over a city gate or on a cathedral facade or, beginning with Leo X, on the Capitoline Hill to symbolize the temporal and spiritual powers of the papacy. The first major portraits of Pope Julius—the sculpture by Michelangelo for the facade of San Petronio at Bologna (1506–8) and that at Ascoli Piceno (1507–10)—belonged to this tradition and were probably influenced by the

example of his uncle Sixtus IV at Assisi. These front-facing, hieratic images, usually larger than life and dressed in full pontificals, were very different from the intimate and obliquely turned figure in Raphael's *Julius*. But there were close similarities between Raphael's pope and the seated popes in votive paintings, dedication pictures, and scenes of papal audiences which had branched out from the strict honorific type by the mid-fifteenth century. It has been suggested that several of these variations derived from a lost *Portrait of Eugenius IV* painted by the French artist Jean Fouquet in Rome between 1443 and 1445. If the evidence of later engravings and the apparent borrowing by Filarete for his doors at St. Peter's are any indication, Fouquet's Eugenius was seated full length at an oblique angle in nonliturgical dress; his entourage stood around him and the "cloth of honor" of French royal iconography hung behind him (Plate 5). Whether through Fouquet's example or otherwise, these motifs had appeared repeatedly by the early sixteenth century in painting, manuscript illumination, reliefs, and medals representing the pope.

Raphael's first painted portrait of Pope Julius as *"Pope Gregory IX" Receiving the Decretals* shows that he was aware of these developments just before beginning the London panel (Plate 6). On the other hand, the grand scale and romanizing, even archaeological, effect of this fresco suggests that he looked farther back than the fifteenth century to classical art. He might well have been inspired by the *Liberalitas* relief on the Arch of Constantine. Or he might have

learned from the relief of an emperor receiving cap-
tives which Julius had placed in the Belvedere
sculpture court. The Roman prototype of an en-
throned and angled central figure was obviously not
lost on Raphael (Plates 7–8).

Two additional motifs of the London portrait—
the knee-length view and the casual dress in *camauro*
and *mozzetta*—figured neither in the mainstream of
papal portraiture nor in Raphael's slightly ear-
lier fresco of Julius-as-Gregory-IX for the Vatican
Stanze. But there were precedents here too, prec-
edents so specific and so rare in all but portraits of
Julius's uncle Sixtus IV that Raphael and his patron
must have had them in mind. The only knee-length,
seated papal likeness known to us is that of Sixtus IV
painted about 1474 by Justus of Ghent for the *studiolo*
in the ducal palace of Urbino (Plate 9). This painting
belonged to a series of twenty-eight famous men
from antiquity to the present—Sixtus represented
the up-to-date theologian—chosen to inspire the be-
holder with lessons of wisdom and virtue. As in the
London *Julius,* the likeness that hung in Raphael's
hometown was turned partially to one side and
seated three-quarter length. The figures in both pic-
tures filled the corner of a room draped with a
cloth of honor. The lowered head of Pope Sixtus
wore a contemplative expression; one hand was ac-
tive, the other passive—as head and hands were
to be rendered in Raphael's *Julius.* Apart from dif-
ferences in size and scale, the principal distinc-
tion between the two portraits was the costume.
Another Sistine precedent suggests itself among

the very few known paintings before Raphael's of
a pope in informal attire. For, dressed in *camauro*
and *mozzetta,* none other than Sixtus IV appeared
in Melozzo da Forlì's fresco of *Platina's Appoint-
ment as Prefect of the Vatican Library* (1476–77) and
the crude fresco variant of this scene for the Hospital
of Santo Spirito in Rome (Plate 10). Melozzo's fres-
co included, with other papal nephews, the future
Pope Julius, who, as cardinal, had supervised his un-
cle's projects at Santo Spirito. The Sistine lineage be-
hind Raphael's panel could hardly be more direct.

Formally, then, as a papal portrait, the *Julius* was
at once a creative synthesis and an innovation. Tradi-
tions of papal portraiture have carried us far enough
to suggest that painter and patron depended on cer-
tain choices within a repertory of inherited pos-
sibilities. At the same time, the papal precedents
were partial and particular—nothing so much as a
ready-made prototype. What they have not prepared
us for is a naturalness and intimacy so complete as to
set the London panel apart from the relatively iconic
quality even of Pinturicchio's Alexander VI or of its
own immediate predecessor in the Vatican *Stanze* by
Raphael himself (cf. Plates 4 and 6). And then—it is
odd that this has not, at least to our knowledge, been
observed before—Raphael's *Julius* was the first inde-
pendent painting of a single pope in the history of
art. So far as papal portrait traditions were concerned,
these characteristics defined something of the formal
inventiveness in Raphael's work. But here again
synthesis was involved, in this case the consolida-

tion of important debts to another Renaissance tradition—the independent secular portrait.

It is possible that Raphael's *Julius* was a direct, if distant, descendant of the late medieval ancestors of this genre. Independent portraits seem first to have been used to represent the kings of France. The earliest surviving example is the small, quarter-length profile (c. 1360–64) of the French king John the Good (Plate 11). Angled against a green cloth of honor, Fouquet's *Portrait of Charles VII* illustrates elaborations on the basic pattern at the middle of the fifteenth century (Plate 12). Together with his influential seated-figure-with-entourage in the lost painting of Eugenius IV, the French painter may have brought this royal portrait type to Rome. The bearded profile of Pope Julius in winter dress, painted by an anonymous artist and known only from a later copy, seems to have reproduced the prototype (Plate 13). In any case, if precedent were needed for an intimate view of an exalted personage, there was none better than the unabashed revelation of royalty by Fouquet and other northern artists. Then too, portraits such as Fouquet's were meant, like Raphael's, to hang on walls; still more suggestively, Fouquet's *Eugenius IV* hung in the sacristy of Santa Maria sopra Minerva, just as Raphael's *Julius* may have hung, when not on display for feast days, in the sacristy of Santa Maria del Popolo.

But there were much closer connections between Raphael's work and the development of indepen-

dent portraiture in Florence. The panels of private
persons which began to appear in Florence during
the 1430s and 1440s were evidently painted to hang
in the palaces of Florentine families to keep alive
the memory and the inspiration of their ancestors
(Plate 14). These characteristically rigid, highly ide-
alized profiles suited their commemorative, even
ritual, purpose. By the third quarter of the fifteenth
century painted portraits and sculpted busts began to
take on the features of living persons over a wider
range of poses, and so began to convey a far greater
sense of naturalness and personal presence. Botticel-
li's *Portrait of a Man with a Medal of Cosimo de' Medici*
from the 1470s is an especially revealing example of
the new type, since the combination of a com-
memorative medal of the dead Cosimo with the
image of a living man seems to capture its develop-
ment in a moment of transition (Plate 15). Around
the turn of the century the transition was virtually
complete, and it was then, between 1504 and 1510,
that Leonardo painted the *Mona Lisa* (Plate 16).

Leonardo's example was crucial not only for the
Julius but also for most of Raphael's later Florentine
and Roman portraits. Through infinitely subtle gra-
dations of tone and modelling, a prodigious under-
standing of the workings of anatomy and nature,
and a keen sense of an underlying harmony pervad-
ing all things, Leonardo created an image of such
graceful animation that previous portraits looked
wooden by comparison. To accommodate the pose
of the first explicit "sitter" in the history of indepen-
dent portraiture he invented a new half-, almost

three-quarter length format. But despite the aura of life, Leonardo was not interested in the particularity of the sitter. The setting was obviously an imagined one, its loggia seemingly suspended in a cosmic landscape. Mona Lisa became an archetypal mother-goddess through the geometrical perfection of her form, her preternatural mass, and the abstract clarity of the architectural framework against a god's eye view of the world. She could hardly be imagined on the streets of Florence.

From Raphael's two Doni panels (c. 1506) to his *Portrait of a Cardinal* (c. 1510) we see the apprentice absorbing the impact of Leonardo while attempting to invest his own work with the observation of physical and psychic uniqueness (Plates 17–19). One *could* imagine Maddalena Doni in sixteenth-century Florence. Yet the sharply rendered details of her costume and physiognomy seem superimposed on the highly abstract design, thick torso, and generalized landscape derived from Leonardo. The pendant *Portrait of Agnolo Doni* was more vivid for the looser geometry of its composition, the varied silhouette and topography of the face, the angled and asymmetrical placement of the figure in space. Still incompletely absorbed, however, the Leonardesque ideal forced itself into the contradictory impulses of the stabilizing balustrade, the bent right arm tying the sitter to the format despite the extension of the torso beyond it, and the broad handling of costume, landscape, and color. The disjunction between the ideal and the real remained, and it was only in the *Portrait of a Cardinal* that Raphael

achieved a fully effective and harmonious balance of
intentions.

The formula for the *Cardinal* set the standard for
many Renaissance portraits that came after it,
Raphael's own *Portrait of Julius II* among them. The
example of Leonardo was apparent in the central
placement of the figure, the rendering of the sil-
houette in simple geometrical forms, the anchor-
ing arm parallel to the bottom edge of the panel, and
the palette of limited range unifying the interplay
of forms. But Raphael also adopted certain devices
to overcome the conflict between general and par-
ticular, between abstraction from and representation
of appearances, which had been so conspicuous in
the Doni portraits. Reduced to a neutral foil, the
background cooperated with the strongly focused
light to project the turned bust of the sitter forcefully
into space. The painted surface displayed a newly
won technical virtuosity which served to communi-
cate a physical and psychological presence perhaps
no more real but certainly less remote than Mona
Lisa. The positioning of the figure in the *Cardinal*
was more casual, the geometry less regular, the color
more intense than Leonardo would have allowed.
The intermingling of an idealized and a contingent
vision may have been less exalted in Raphael; but it
was also more accessible.

For the London *Julius,* Raphael refined the formula
of the *Cardinal* by adding a backlight to enliven the
background and create a spatial ambience for the sitter.
In contrast to the *Mona Lisa,* the setting became a
real-seeming corner of a room. The rendering of sur-

face and psyche were now of a nuanced subtlety equal to Leonardo's, but even more individualized than in Raphael's earlier work. Rather than the murky light and labored execution of the *Mona Lisa,* rapidly executed finishing touches of thickly painted but finely lined highlights created a far more convincing illusion that the observer views the portrait with the sitter bathed in natural light. But for all the freedom and vivacity, Raphael employed a clearer, grander, and more stable structure than he had contrived for any of his previous portraits. The chair, the corner of the room, and the pope's body were carefully composed to form a solid pyramid locked within a grid of verticals. The refined modulation of detail, the convincing anatomy, and the sculptural presence of the forms testify to much painstaking effort, several days at least and probably longer judging from the revisions, or *pentimenti,* disclosed by X-ray photographs.

The fusion on the National Gallery panel of spontaneous creation, careful concentration, and attention to precedent can be put to one final visual test. Raphael was probably not so intimate with the pope as Vasari wanted to believe. But his wonderfully fresh, quickly sketched Chatsworth drawing of Julius's head suggests that the harried pontiff did "sit" at least once, just as Federico Gonzaga was to do a few months later, when the painter "made a charcoal sketch for later use" in a room in the Vatican Palace (Plate 20). On the other hand, if what appears to be a heavily reworked cartoon for the *Julius* in the Corsini Gallery in Florence is authentic, it was among the first ever made for a portrait—and one

more indication that a period of careful calculation preceded the moment when Raphael first laid his brush on the London panel.

Contemporaries noted the simultaneous interplay of precedent and invention in Raphael. Already in the 1520s Paolo Giovio was writing of the painter's quick powers of assimilation—and of what Giovio chose to consider a conflict between artifice and nature in his style. Vasari elaborated in his *Lives*. Raphael had been the great and gracious inventor, but also an artist "who, studying the works of ancient masters and those of the moderns, took the best from all and, having assembled them, enriched the art of painting. . . ." Ludovico Dolce varied the theme but slightly: Raphael "did not paint at random, or for the sake of practice, but always with much application." The painter's first aim had been to imitate the best models—*la bella maniera delle statue antiche* was Dolce's example. The second was "to contend with nature."

These judgments are revealing in themselves. They help describe and confirm what we have seen on our own. But they should also lead us from considerations of motif and form to questions about their cultural context. What were the enabling circumstances and available categories for what we have seen and now, from contemporaries, have heard about Raphael? What was there, after all, in the Julian setting that permitted or positively encouraged the blending of synthesis and invention, or of the calculated effect and of naturalness, which seems to define the individualism of Raphael's *Julius?*

These are difficult questions, but they are at least questions of a sort that would have been understood in the High Renaissance. The special character of any culture reveals itself along the interface between received conventions and the particular instance, and this was an especially self-conscious concern in the Renaissance world. Whatever was "Renaissance" depended, by definition, on both the prescriptive authority of models from the past and the commitment to make them live—or re-live—in the present. As a result, tensions between past patterns and present possibilities, archetype and experience, prescription and invention, norm and nature became the underlying calculus of creativity in the Renaissance style. If the style of Julian Rome can be described at all accurately as *High* Renaissance, it is largely because these tensions were so intensely felt and acted out in the prevailing culture. Raphael's *Julius* was clearly no exception.

But there are quite specific points of cultural access to what we have seen so far in the portrait. The principle of imitation in literature and art, for one, was a favorite theme of Renaissance scholars and writers after Petrarch, not least among *literati* close to Raphael and the Julian court. This is understandable, in the first place, because a central Renaissance issue was at stake: how could the language, the imagery, and so the culture of antiquity be appropriated for the uses of the present? In the second place, the ancient authors so much admired in the Renaissance had practiced and prescribed a rhetoric of imitation. Traditions transmitted by Cicero and Quintilian emphasized the need to balance the formalism

of training in approved models *and* an inventive openness to observation and discovery. "Rhetoric," Quintilian had explained, "would be a very easy and small matter, if it could be included in one short body of rules, but rules must generally be altered to the notions of each individual case, the time, the occasion, and necessity itself."

By the early sixteenth century the question of whether to imitate had long since been resolved; what had been the imaginative discovery of a few had become a commonplace of humanist studies and schoolrooms and, eventually, a habit of mind. The question was rather how to imitate—whether, for example, to stress the absolute authority of precedent over invention; or, again, whether to follow many or only a few models. The stricter formalist position had gradually centered on a quite un-Ciceronian insistence on the authority of Cicero as opposed to the free imitation of a wide range of ancient authors. Opinion divided along similar lines over *la questione della lingua*. The vernacular had come to have its classics too. Should the "good Tuscan" of Petrarch and Boccaccio be imitated exclusively then? Or should one write in the polyglot Italian of the courts, drawing on the best models from different times and places?

A famous controversy on these questions broke out in Rome just after the completion of Raphael's *Julius*. Preliminary skirmishes may have begun while Raphael was actually at work on the London panel; both parties to the dispute must have been well known to the painter and his patron. The exchange of letters *de imitatione* between Gianfrancesco Pico

and Pietro Bembo reads, in any event, very much like commentary on the creative processes Raphael's *Julius* seems to presuppose. The case for combining many models with one's own ingenuity was precisely Pico's challenge to Bembo. "I have decided," he wrote in Rome on 12 September 1512, "that there should be some imitation but not continual, and that all good writers should be imitated, not some exclusively nor wholly but just as each one thinks safe." This had been the practice of the ancients; they "took from any source whatever and as much as seemed to strengthen or adorn their phrase and was recognized as appropriate to the theme." It was also natural, "since Nature distributes her gifts to one and all in such a way that the standard of beauty is established from the variety." Besides, it was the technique of good teachers to "place many models before us." Pico clinched his case with the tale of the Greek painter Zeuxis, who had painted the features of many maidens in creating the perfect image of one beautiful woman. This was a cliché, a well-worn link between literature and art. In literature and in painting—*ut pictura poesis* in the famous formula of Horace—Pico expected writers and artists to follow many examples with the guidance of their own innate judgment and the standards they had learned in practice.

Pico might have been describing the making of Raphael's *Julius*. But Bembo's reply should not be passed over as an irrelevant Ciceronian exercise. The arch-Ciceronian appreciated the power of the eclectic ideal. Replying in Rome to Pico on 1 January 1513,

Bembo admitted to having practiced it himself for years. Only after "much thought and through many steps" had he concluded that nothing but the best and most complete models—Cicero in prose, Virgil in poetry—should be imitated. Granting the premise that imitation was desirable, Bembo's argument was forthright, even compelling. And, even more than Pico, Bembo drew support from the analogy of painting. Ancient artists, he argued, could copy from pictures by Polygnotus and Thymantis, but they had learned most from Apelles, the greatest master of them all. One thinks of the decisive role Leonardo's example played for Raphael. One thinks too of the impact of Pope Julius's actual presence in Bembo's assertion that even artists who learned by imitation, "when they desired to fashion the portrait of Alexander, kept their mind and eyes on him alone." Finally, Bembo offered a rationale for what the most careful tracing of precedent must in the end confirm in Raphael's *Julius:*

I limit the method so that if anyone is superior, industrious, or fortunate enough to surpass his master he ought to do so. Indeed, I quite approve of Phidias who excelled Eladus in sculpturing. Polyclitus who surpassed his master in painting, and Apelles, who left his teacher far behind.

This network of ideas running close by (and surely through) Raphael's *Julius* did not stop at Pico or Bembo. It extended back to early humanist discussions of art which, as Michael Baxandall has shown, were predicated on the application of class-

ical rhetorical theory to the visual arts. In his treatise *On Painting* (1435) Leon Battista Alberti had already recommended to painters Pico's eclecticism, Bembo's concentration on one model, and the lessons of nature; in his short work *On Sculpture* (after 1443) he adapted rhetorical distinctions between the general category and the particular case in an analysis of verisimilitude—truth to type and to the specific instance—in portraiture. Closer to Raphael and his patron, Mario Equicola, writing from Julian Rome in defense of a courtly vernacular, singled out the Roman court as an ideal center for imitation with distinguished results, since there were in Rome "outstanding and most excellent men from every region [of Italy]." If encouragement to master one model *and* to draw on many models were necessary, Baldassare Castiglione would have provided it. Castiglione was Raphael's friend and correspondent; he had been a companion of Pope Julius at the siege of Mirandola and was a familiar figure at Della Rovere courts in Urbino and Rome. In the *Book of the Courtier* he advised "the good pupil . . . to transform himself into his master"; then "to observe different men of his profession and, conducting himself with that good judgment which must always be his guide, go about choosing now this thing from one and that from another." It seemed no contradiction to Castiglione that such studied imitation could be made to appear perfectly natural. That was the essence of the desired effect of *sprezzatura,* that double duplicity which transformed nature into art and art into the appearance of naturalness.

Only one more variation on these themes could bring us still closer to Raphael and his *Julius*. It was Raphael's own. In 1514, in a famous letter to Castiglione, the painter took up the great commonplaces for himself:

To paint a beautiful woman, I would need to see many beauties, with the condition that your Grace join me to choose the best. But lacking good judges and beautiful women, I make use of a certain idea that comes into my head. Whether it has any excellence as art I don't know; at least I try very hard to have it.

This has been called "a curious notion." Roots in Neoplatonic or Aristotelian philosophy have been solemnly proposed for it. Raphael's letter was wonderfully playful, but it was "curious" only if the painter and his culture were; and it was not so much a philosophical argument as a bow to the impulses of a common culture. Fifteenth-century writers on art had often emphasized observation of the natural world, just as, in practice, artists such as Leonardo or Pollaiuolo had often chosen to concentrate on the workings of nature. Half a century after Raphael, theorists of the Ideal were drawing sharp contrasts between ideal and actual visions of the world. It seems somehow characteristic of the culture of Raphael and his patron that creativity seemed still so flexible, that "ideal" and "real" perceptions, or the play of precedent and of inventiveness, could still be held in balance.

Similar combinations in contemporary ways of perceiving an individual derived from another set of

attitudes and ideas. Raphael's contemporaries were used to reading the underlying character of an individual in his physical appearance. They owed this skill in the most general sense to the old commonplace of a pneumatic psychology that physical attributes were related to the actions of the soul. This assumption had been refined by a literature on physiognomics and by still other inheritances from the classical rhetoricians—for example, their views on expressing "the spirit in the letter"; and the standard topic of the "living likeness" or the "speaking image" in their discussions of art. The physical codes of mental and spiritual qualities were a major theme in the treatises on painting by Alberti and Leonardo. "Let the attitudes of men and the parts of their bodies be disposed in such a way that these display the intent of their minds," wrote Leonardo on one of many pages analyzing "the movements of the soul in bodily appearances." Otherwise painting would be a lifeless thing, since it "is not in itself alive . . . and if it does not add the vivacity of action, it becomes twice dead."

A chapter on physiognomy from Pomponius Gauricus's dialogues *De Sculptura* (1504) can be read as a Julian guide to physiognomical lore. Since the thirteenth century, scholastic philosophers in the universities had drawn from a rich tradition of Greek and Arabic writing on physiognomics. The original, pseudo-Aristotelian texts (Gauricus based his chapter on one of these) were recovered and reexamined by humanist scholars, while artists applied rule-of-thumb versions with a frequency and familiarity that Alberti and Leonardo only begin to suggest. This

confluence of precedent and practical exploration describes a characteristic pattern in Renaissance culture. By bringing these strands together, Gauricus, who may have been in Rome while Raphael was painting the National Gallery panel, played his part in an equally characteristic High Renaissance, and Julian, kind of culmination.

Rather than the *tabula rasa* of Burckhardtian individualism, Raphael and his contemporaries had these cultural cues and categories to bring to the spectacle of Pope Julius. It is true that, where literally applied, Renaissance physiognomics produced grotesque exaggeration or stereotype, not Raphael portraits. But diffused, as a habit of mind, the common stock of physiognomical ideas did sustain a conviction in the substantive reality of particular physical appearances and in the significance of physical differences among individuals, both in themselves and as mirrors of individual temperament and the individual soul. The physiognomical mask reflected the man; the man portrayed the mask.

This may help us understand how the aspect of a "choleric" type and the features of a pope at a particular moment could seem practically indistinguishable in Raphael's *Julius*. The flushed complexion of the likeness and the strong forehead and nose signalled, in a physiognomical key, high spirits in general, irascibility in particular. The dark eyes, moderately recessed, confirmed and extended this interpretation. According to a passage from Gauricus, "[such eyes] will betray a huge spirit, a great soul for effecting great deeds, but then too those prone

to rage, the drunkards, and those who strive for glory over mankind. . . . " Beards too—beards quickly grown at that—had a place in physiognomical lore as a sign of fiercely determined character. There was even room for one of the subtlest effects of Raphael's characterization: the ruddiness which signified a propensity to wrathful passion was also held to reflect pain and profound meditation.

The overall impression could have been seen as at once accurately descriptive and "leonine." The leap by analogy from men to the animals they were supposed to resemble was a commonplace of physiognomical literature and, as has been shown for the leonine type at least, of Renaissance artists. Alberti's deliberately leonine mask on a self-portrait medal, Verrocchio's experiment with the warrior's snarl in the Colleoni monument, and the lionlike visage of imperial majesty on Cellini's *Bust of Cosimo I* are telling examples. Between the rigidity of experiment in the Quattrocento and of propagandistic intent in the Cinquecento a medal of Julius, struck perhaps in 1511, gave him a conspicuously leonine appearance. One wonders about the square face and hanging cheeks, the clamped mouth and the prominent forehead, with its suggestion of a "clouded" brow, in Raphael's portrait. Do these features of his *Julius,* however subtly modulated, betray the lion's mask? We can only be sure that the conventions of the leonine type were such and, furthermore, that the significance attributed to them would have suited the Julian image. The leonine individual was taken to be strong, virile, inclined to anger and fury, but

also, with the brooding power of the lion, capable of mastering terrible passions. The lion-man merged with the archetypical classical hero, with Hercules, and with his Christian transformation already discussed by Lactantius and elaborated by Renaissance writers as a symbol of Christlike righteousness. It is a tempting network of associations, the more so because it is easy to imagine them tempting Julius himself.

Where did the "norm" end and "nature" begin? The point—the High Renaissance point—is that such distinctions were not sharply drawn in the Julian world. In creativity and in perception, commitments to categories and experience or to prototype and invention were widely held to flow into, not against, one another. What we see in Raphael's *Julius* had, in short, its cultural vocabulary and rationale.

It also had its metaphysic. Raphael had scarcely finished his work when Machiavelli expressed the hopeful wisdom of his contemporaries that the creative power, the *virtù,* of great individuals might master the circumstances and precedents, the *fortuna,* that faced them. Pope Julius was one of Machiavelli's prime examples. In sermons the Julian court heard preached in the Sistine Chapel, and could see illustrated in Michelangelo's vault above, man was proclaimed made in the image of God but pronounced free to fashion the likeness he chose for himself. Within a few months of Raphael's portrait Pope Julius convened the Fifth Lateran Council, where the doctrine of individual immortality was first officially established. The Aristotelian position that the soul

was universal and indivisible among merely mortal men was rejected. If the Fifth Lateran decree was logically and perhaps biblically dubious, its historical relevance was not. For the aspirations of Julian culture, like Raphael's *Julius,* depended on the conviction that the identity of the individual was at once beyond time and of the moment, that the soul, as the Lateran fathers decreed, was immortal, but only "in the bodies in which it is infused and capable of multiplication in the multitude. . . ."

Yet culture is not strictly a matter of ideas, and we would miss much in the individualism of Raphael's *Julius* by supposing its cultural significance limited to intellectual principles for their own sake. The London panel, like any artifact, can also be said—and seen—to have contents derived from institutional, political, and in the broadest sense, social circumstances of its making. This need not commit us to a heavy-handed material determinism to explain the particular sort of individualism—the fusion of precedents, invention, and naturalness—we have found so far in Raphael's portrait. But it should lead us to expect those qualities to have referents and relevance as products, if also as conditions, of the society inhabited by the painter and his patron.

Consider the fact that Raphael's *Julius* represents a papal *persona* and the utterly particular person of the pope. General type and specific instance merge in a masterful way. This combination can be read simply as one more variation on what should seem by now a familiar pattern. Our analysis could stop there. But a moment's reflection suggests further possibilities,

not least that the *Julius* recorded and, indeed, depended upon the kind of individual presence Renaissance society tolerated or actually demanded in a pope.

Something like a cult of personality was deeply rooted in the history of the papal institution, especially in its development during the fourteenth and fifteenth centuries. To the extent that a pope was thought to embody the powers of his office in succession from St. Peter, the office could be identified with the man, for all the attempts of conscientious theorists to keep them distinct; and to the extent that the pope was absolute, as papalist writers insisted in proportion to the intensity of contradiction, there was little in theory to gainsay the style, effective or not, of a strong-willed individual in office. Ernst Kantorowicz devoted key parts of a great book to the ideology behind this process of personification. In the early Middle Ages, he observed, the "mystical body of Christ" had designated the host consecrated in the Mass; by the middle of the twelfth century the formula was being applied to the institutional organization and administrative apparatus of the ecclesiastical hierarchy. What had been liturgical and sacramental in meaning became a sociological description in response to the elaboration of institutions within the Church and challenges from secular powers without. The next step was to associate the "mystical body" with the head of the hierarchy—the pope himself.

This association was not a mere debating point, interesting only to theologians and lawyers. It was

an efficient political weapon in times of trouble for
the papacy after the early fourteenth century. Bon-
iface VIII and his supporters were testing it at
the beginning of the century in their hard-fought
confrontation with Philip the Fair of France. To
show that popes surrendered nothing for their long
residence at Avignon (1305–78) the claim was re-
peated over and over again that "the mystical body
of Christ is where the head is, that is, the pope." Not
only Rome, but Jerusalem, Mt. Sion, the "dwellings
of the apostles," and the "common fatherland" of
Christians—*all* these were where the pope was, papal
apologists proclaimed, "even were he secluded in a
peasant's hut."

That the Church was drawn still more closely
around the hierarchy, the curia, and their single head
was the most lasting, if most paradoxical, effect of
the division of Christendom among rival heads be-
tween 1378 and 1417. By the mid-fifteenth century,
the period of the Great Schism and the church coun-
cils, with the "parliamentary" resistance growing
out of the conciliar movement, could be made to
seem an unfortunate aberration which might be laid
to rest. The pope had been reestablished once and for
all in Rome; the central institutions of the Church
were more dependent on him than ever. Speaking
for the hierarchy in the person of the vicar of Christ,
Pius II's famous bull *Execrabilis* (1460) condemned
any presumption of appeal to a General Council
"from the ordinances, sentences, or mandates of our-
selves or of our successors. . . ."

Half a century later the theme of Christian unity

in the body of the pope was often invoked. The fathers of the Fifth Lateran, warding off yet another time of crisis, referred to it again and again. When Cipriano Benet dedicated a treatise on the Eucharist to Pope Julius, he associated the miracle of the Mass with the presence of divinity in the pope. So did Raphael in the *Mass of Bolsena* (Plate 21) and in the *Disputa,* where Julius was probably depicted in the guise of St. Gregory the Great and was, in any case, named in two inscriptions on the altar. Julius contemplated and adored the host. He witnessed and confirmed the miracle of Transubstantiation which sanctioned in turn his spiritual power and his office as Christ's vicar.

In important ways, then, the self-display of Renaissance popes was not an inroad of secular society on religious values and institutions. But it *was* that too. No exaltation of the papacy, even (perhaps especially) when meant to shield the Church from secular ambitions, could conceal how much the popes had compromised or lost; on the contrary, ideals of papal supremacy promoted worldly interests at the center of the Catholic world. Although Denys Hay has most recently reminded us how little is known about the actual workings of the Renaissance papacy, the secular orientation was glaring enough. Stories of "bad Renaissance popes" have, if anything, been told too often, with little regard for the pressure of historical circumstances. Economically and politically vulnerable abroad, Renaissance popes were thrown back on their Italian possessions, where they were often forced, if they did not choose, to play politics as Italian princes

did. Their revenues had fallen sharply as a result of the Schism and the councils, and by the 1470s they depended on the Papal States for more than half their income. Clerical discipline was lax, a casualty in part of generations of distraction and lay interference. The shambles Rome had become could not be rebuilt on pure spirit. And if papal politics were blatantly dynastic (not for the first time, it should be remembered), it was partly because the growing monopoly of Italian families on the papacy and the highest offices of the Church had linked ecclesiastical affairs to an insatiable system of secular demands.

Whether for sacred motives or profane, by 1511–12 the personal touch and presence of Renaissance popes had broken openly through and merged into an official *persona* which had itself become ever more exaggerated. The anthropologist Mary Douglas observes that any "physical experience of the body, modified by the social categories through which it is known, sustains a particular view of society." It is a notion papal apologists, courtiers, image makers, and quite ordinary Christians were equipped to understand. The more a society is segmented and divided by hierarchical distinctions, Douglas maintains, the more the ego of its leaders will have full play. Her analysis of the leader relatively unchecked by bonds of group solidarity might have been intended for Pope Julius:

He sees the powers which dominate [the cosmos] as available to anyone for the grasping. Courage, determination and cunning are the list of respected virtues. To his own personal endowment of these he owes his own success. But

there is no rational explanation of how he came to earn or deserve his advantages.

Moving from the leader to his followers in a divisive social setting, Douglas describes how they must seek a center and a focus to compensate for disunity in society as a whole. The figure at the top comes to epitomize the separate and self-serving disposition of the various levels of society; at the same time, his authoritative (and authoritarian) presence guarantees and legitimates the social hierarchy through the subordination of its parts to him. In such a world—for the sake of argument, in the world of Pope Julius—social interests speak, and show, through the individualism of the ruler, which is far from being his alone.

We should not be surprised that Raphael's *Julius,* image that it is of charismatic papal leadership, would seem tangibly real and authoritatively ideal. The believable presence in an idealized form was one more means through which society could be persuaded to believe in itself. Like deeper miracles, it could authenticate existing arrangements and aspirations, and analogies with the "mystical body," the Real Presence in the celebration of the Mass, or even the Incarnation did not seem blasphemous to many inhabitants of the Julian world. Papal display could sanction the official functions and sacred mystique of the ecclesiastical hierarchy; it could stand surety for bankers' credit on "Saints Albinus and Rossus," white silver and red gold, to the Holy See. Through the person of the pope patronage could be extended,

provincials made cosmopolitan, and Romans assured that pilgrims, profits, and high style would flow to the city. Had the greatest artists not glorified the papal image, lesser ones would surely have been called to do so.

While Raphael's representation of the *persona* and person of Pope Julius presupposed both old uses of charisma and the new Renaissance environment in the history of the papacy, the London panel also incorporated another presence at least as individualized as its subject's. As surely as Pope Julius, Raphael was there, unseen but actively establishing the perspective of the beholder, monumentalizing an otherwise fleeting image of nature, investing *his* portrait with a unity of conception greater than the sum of its parts.

This self-conscious mediation by the painter would hardly have been possible if artistic enterprise had been organized as a strictly corporate, more or less utilitarian form of manual labor on the guild model. As a social type, the guildsman strives to conform to traditional standards and so to merge his creative identity into impersonal rhythms of work and rewards. He provides a social service. In his world, paintings, sculpture, or buildings are produced in the same manner as shoes or hardware, or the banners, furniture, and costumes still made by Renaissance artists. Raphael could never have remained an ordinary apprentice even if he had stayed in Urbino. The point is worth making, however, that by the end of the Quattrocento

the circumstances in which works of art (or at least of painting) were made positively encouraged artists to develop a personal style.

It is true that the craft tradition persisted much longer than Renaissance writers would have us, or their own contemporaries, believe. Recent studies have qualified the notion that Renaissance artists adopted a modern pattern of work—what is tempting to call the garret model, according to which artists operate as creative individuals, cultivating a more personal style and a more cosmopolitan culture than the craftsman in the workshop. Few, if any, artists met Alberti's ideal of the learned and virtuous painter; none could match him at citing the classics—certainly not Raphael, who apparently did not know Latin. And, as Peter Burke has shown in an analysis of the creative élite in Renaissance Italy, painters, sculptors, and architects continued to come mainly from the artisan and shopkeeper class; the writers and scholars were, like Alberti himself, mostly descendants of nobles, merchants, and professionals. Nevertheless, the elevated personal and professional status Renaissance writers envisioned for artists did not remain altogether theoretical or wishful thinking. It was only after contacts with Florentine artists in the 1430s that Alberti wrote *On Painting,* confident in the power of art to master nature through individual minds and eyes. Artists themselves may not have put the practice of perspective construction on a theoretical footing or set the arts in the mainstream of humanist culture, but many came to associate, as Alberti thought they must, with learned men who "have many ornaments in

common with the painters" and "are full of informa-
tion about many subjects."

The growing prestige accorded to personal style
and invention can be documented in the few hun-
dred contracts between patrons and artists which
have survived for the fifteenth and early sixteenth
centuries. For all the variations due to time, place,
and medium, there is considerable evidence of a few
overarching trends. Provisions for expensive mate-
rials for the sake of sheer display, or fixing style and
subject matter ready-made to the patron's order,
gave way gradually, if not altogether consistently.
Patrons of painting were more and more likely to
buy the artist's brush than showily expensive gold or
ultramarine. The high cost of pictorial skill was
widely discussed and, more impressively, paid for.
By the end of the Quattrocento it was not unusual
for contracts to discriminate sharply between the in-
dividual master and his workshop and to demand
works of his own design and execution. E. H. Gom-
brich's formula—from "commission" to "mission"
—seems apt. In effect, artists were being subsidized
to surpass their rivals and themselves for their own
greater glory, the renown of their patrons, and the
realization of the heady new ideal fostered by these
developments—progress in art.

From the middle of the fifteenth century, Rome
was a vital center for the redefinition of the artist's
social place and professional function. The Renais-
sance campaign of building and decoration in Rome
began after a century and a half of more than the
usual neglect. It was partly a response to the need to

restore the physical fabric of a city of cow pastures; winding, dilapidated streets; broken aqueducts, and a population reduced from a million or more inhabitants in the time of the Roman empire to as few as 25,000 in 1420. To renew the city was also to refurbish its image in line with the restoration of a self-conscious papal supremacy and a *Kulturpolitik* based on the Renaissance recasting of traditional principles attributed to Nicholas V, the pope responsible for the great jubilee of 1450:

. . . to create solid and stable convictions in the minds of the uncultured masses, there must be something which appeals to the eye; a popular faith, sustained only on doctrines, will never be anything but feeble and vacillating. But if the authority of the Holy See were visibly displayed in majestic buildings, imperishable memorials and witnesses seemingly implanted by the hand of God himself, belief would grow and strengthen from one generation to another, and all the world would accept and revere it.

In this atmosphere, popes and prelates, aristocrats and international bankers drew artists and architects from all over Italy to Rome with that special sort of atavism inspired by new ambition and wealth. Even Pastor, who resorted to counting works of religious art in his *History of the Popes* to prove the Catholic sincerity of the Quattrocento, was staggered by their apparent quantity and cost in Rome.

It was like Pope Julius and like Raphael to make the most of their chances in what had become a boom

town for art. Julius had been schooled in its uses by the most extravagant papal patron of the fifteenth century, his uncle Sixtus IV. He seems to have become a kind of artistic adviser to Innocent VIII, and he plainly meant to surpass Alexander VI as a patron of art. His expectations as pope for the greatest artists on the most grandiose projects are a matter of record; otherwise we could only consider him, as satirists were quick to do, a Renaissance patron in caricature. But Raphael himself, already *the* Renaissance painter in 1511–12, was practically a living myth in his own right. He had been summoned to Rome in 1508 at the age of 25 after a kind of triumphal progress through commissions at Urbino, Perugia, Siena, and Florence. With stunning facility he had learned at every stop and adapted his style to the lessons of important sources wherever he found them. Once in Rome, he was chosen to complete the painting of Julius's own apartments, where, by 1511, he had inserted his own portrait among the pagan and Christian immortals of the *Stanza della Segnatura*. Through painting he became more than a painter—courtier and familiar of the great, connoisseur of antiquities, prospective son-in-law of a cardinal, builder of his own palace, and a wealthy man. It measured his own special genius but also how far an artist could rise that near-contemporaries thought of him in terms they applied to his patron. Raphael, too, was a "prince," "divine," "a mortal god."

But there were limits. Artists in Julian Rome were certainly not free agents, as even the greatest among them were reminded on more than a few occasions.

Julius quashed Bramante's plan to reorient the new St. Peter's on line with the Vatican obelisk. Michelangelo was forced to submit to Julius with the symbolic noose around his neck after fleeing from a real or imagined papal insult in Rome, and arbitrary changes in his plans for Julius's tomb by the pope and then his heirs tormented the sculptor to the end of his life. Payments rarely kept pace with the artist's or the patron's ambition. The very scope of Julius's projects was a source of frustration because, as in the famous case of St. Peter's which took more than 100 years to build, it was rarely possible to see them through to completion. With all the willfulness and the power of humiliation a prince could command the court obviously lay between the Guild and the Garret. The obverse side of the artist's new dignity and freedom was a new kind of servitude. Even Raphael, ever able and adaptable, complained with feeling from Rome that an artist knew "what it meant to be deprived of one's liberty, and to live obligated to patrons. . . . "

Even so, Julian commissions were of unrivalled scale and opportunity. The pope listened to artists as he did to few other men, and he did not hesitate to raise his terrible stick against the unfortunate *monsignore* who dared to say against Michelangelo that artists were "ignorant of everything except their art." Raphael's portrait was one of many rewards of the vision—and the historical experience—behind his patron's blows.

In the end, it is true, we are left to imagine what the encounter between Pope Julius and Raphael was re-

ally like. Of experience as it was actually lived we have only outcomes, objects, and rather inadequate terms for describing them. And since the creative process ultimately escapes analysis, we can only suggest how much even the individualism of Raphael's *Julius* was conditioned by a Renaissance stock of motifs and forms, ideas about the creative process in art, modes of perception, and circumstances of what it meant to be a painter or a pope. Certainly *Renaissance* individualism had little to do with much later manifestations, equally historical in their own time, of free artistic inspiration and outright rebellion against cultural traditions and social norms. If the term is meaningful, perhaps it is because Renaissance individuals—say, Pope Julius and Raphael —could choose and act self-consciously to draw together, and sometimes to extend, the conventions of their culture.

2
Roles of a Renaissance Pope

While a sense of individuality may be immediately
striking in Raphael's *Julius,* the fact that we are look-
ing at a Renaissance pope is hardly less so. This is
not simply a matter of illustration; it is also a result
of those coexisting meanings which make communi-
cation more than a mechanical exchange of proposi-
tions in one dimension. We all know from everyday
experience that whatever a message says on the sur-
face seems always to be qualified and framed by
other messages which amplify, diminish, or actually
negate it. Depending on how and where they are
spoken, the most stylized greetings tell us a good
deal more than "good morning" or "good night." If
this is true of ordinary experience, it is truer still of
the complexly transmitted experience in a work of
art, particularly of art in a culture accustomed to
perceiving various levels of significance in things. In
this chapter we turn from individualism to the fur-
ther, if not necessarily the second, impression we
have on viewing the London panel, that this is, of
course, a Renaissance pope. Here again we shall have
to proceed on a variety of levels, not only because
art does so, but also because Raphael's portrait con-
tains references to so many roles played by Renais-

sance popes—none more grandly than Pope Julius himself.

To confirm the need and take our bearings for this sort of analysis let us look again at contemporary responses to what we might suppose to be only a high touch of Julian individualism—the famous beard. The diary of Paris de'Grassis tells us that the pope let his beard grow from the time of his siege of illnesses at Bologna beginning in October 1510. But even the pragmatic master of ceremonies could not limit himself to mundane explanations such as weakness or lack of hot water. Messer Paris went on to suggest that the beard had something to do, perhaps "through a vow," with the losses the pope had recently suffered at the hands of the French. As a Bolognese chronicler recounted it, Pope Julius "was wearing a beard to avenge himself and said that he did not want to shave it again until he had driven King Louis of France from Italy." Reports from Rome and abroad agreed, and when Julius appeared clean-shaven, it was, according to Marino Sanuto, following Venetian dispatches from Rome in April 1512, "because he saw things were going well." Sources closer to the pope observed that his beard had actually disappeared by degrees in March 1512, as if to mark and conjure up in stages the fulfillment of his vow. The Fifth Lateran Council had been summoned (July 1511) to address the call for reform—and to counter the French-inspired Council of Pisa. Against all expectations Julius had recovered from another nearly fatal illness in time to put down

an uprising in Rome (August 1511). The Holy
League (October 1511) had consolidated his position
in alliances with Spain, Venice, the Swiss Confedera-
tion, and England. With the all but miraculous rout
of the French after their illusory victory at Ravenna
on 11 April 1512 the success of the papal cause—and
the beard—was complete.

That the beard was a symbolic gesture seems
quite certain. In contemporary eyes and quite like-
ly in his own the bearded Julius assumed, at one
level, the identity of warrior prince and even of
an emperor. Erasmus's devastating satire *Julius Ex-
cluded from Paradise* would soon spread this im-
age all over Europe, and the Erasmian picture of
the pope as a soldier king and new Caesar, banging
on St. Peter's gate, was not so far off target. Almost
all the very few Italians shown with beards before
Julius in Hill's corpus of Renaissance medals were
ruling princes and nobles; after Julius's time and, ac-
cording to at least one source, with his specific en-
couragement beards became a standard attribute of
the determination and majesty proper to princes.
They were no less suited to the aspect of an em-
peror. Among other soldiers and rulers the most
celebrated to have sworn by his beard was none
other than that first Julius who, as Pope Julius could
have read in the copy of Suetonius in his private li-
brary, grew a beard in mourning after a defeat by
the Gauls (!) and vowed not to cut it until he had
taken vengeance. So strong were the imperial associ-
ations in Julian Rome that the Emperor Justinian,
traditionally represented as clean-shaven, was shown

with a beard in the *Pandects* fresco—Raphael's fres-
co—for the *Stanza della Segnatura*.

There were other associations and other roles en-
compassed by the gesture of growing the beard. Al-
though Erasmus's St. Peter was reluctant to grant
Pope Julius even the appearance of a priest, let alone
the virtues of piety and holiness, others took the
beard as a distinctive sign of priestliness. That bored
bureaucrats in the curia may have joked about
Julius's beard as the beard of St. Peter does not mean
that the comparison was not taken seriously. Julius's
other namesake, the first Pope Julius, was shown
bearded in a twelfth-century mosaic, and for at least
one Roman, who could not recollect ever hearing of
a bearded pope, the image of a holy hermit sprang to
mind. Giles of Viterbo, addressing the assembled
cardinals at Bologna in May 1511, likened Julius's
beard to that of the high priest Aaron in the Old
Testament. It was an analogy drawn from a text re-
cited in papal coronation ceremonies, and a reference
that fit the needs of the moment. The authority of
Aaron's succession to Moses and so, analogously, of
the succession of St. Peter and the popes to Christ
had been confirmed when God destroyed Corah and
his followers for attempting to usurp the office of
high priest. Botticelli had illustrated the punishment
of Corah by the bearded Aaron in the frescos which
Sixtus IV, in his own campaign for papal supremacy,
had commissioned for the Sistine Chapel. Analogies
between Pope Julius and Aaron would be drawn
again in a triumphal float for the Roman carnival
procession of 1513.

This did not exhaust the spiritual significance of the papal beard. Raphael's own *Expulsion of Heliodorus* (c. 1512) in the Vatican *Stanze* linked the old dispensation in the East and the new in the West by representing the bearded Julius observing and, one imagines, identifying with the bearded high priest who prayed for deliverance in the Temple of Jerusalem (Plate 22). Renaissance allegories converted the bearded sun god Serapis into a Christ-type. And there was of course the ultimate allusion to the bearded Christ himself. By 1529 Piero Valeriano, once a member of the Julian court, could write an entire treatise in defense of priestly beards. Citing precedents pagan and biblical, ancient and modern, he argued that nothing was more pleasing to God or appropriate to the priesthood. Could there be any higher authority, he wondered, than Raphael's likeness of Pope Julius, "made with a beard in the sight of all men?"

Prince, emperor, and priest—the implications of the beard alone warrant a closer look at the roles of a Renaissance pope and their expression in Raphael's London portrait.

In Erasmus's *Julius Excluded from Paradise,* St. Peter was sure what he saw in the pope:

JULIUS: What the devil is going on here? Doors won't open, eh? Looks as if the lock has been changed. . . .

ST. PETER: . . . what monstrosity is this: while you wear on the outside the splendid attire of priest, at the same time underneath you are altogether horrendous with the clatter of bloody

weapons? And then how fierce are your eyes, how nasty your mouth, how baleful your expression, how haughty and arrogant your brow!

I suspect that the most pestilential pagan Julius has returned from the underworld to mock me; so completely is everything in you consistent with him. . . .

JULIUS: Though it is degrading for the famous Julius, hitherto invincible, to submit now to Peter, who is, to say the least, a fisherman and practically a beggar; nevertheless, so you'll know what sort of a prince you're insulting, listen. . . .

Erasmus's imperious warrior prince was *the* Pope Julius for many in his own time. We find this characterization no less savagely turned in the tracts of hostile propagandists and in doggerel complaints from Venice and Rome; we find it acted out in *tableaux-vivants* staged in Paris and broadcast in woodcuts to the wider world (Plate 23). An early sonnet by Michelangelo, the most Julian of artists, played on the imagery of chalices turned into sword and helmet, cross and thorn into shield and blade, in his patron's Rome. "It was," remarked Francesco Guicciardini, ever cautious, "as if Julius were a secular prince." After his election, the pope's Ligurian countrymen were already congratulating him for his "Caesar-like soul," and inscriptions at the coronation ceremonies celebrated "Caesar reborn." More than 400 years later Ludwig von Pastor felt obliged to apologize for what was still the dominant impression.

But apologies were a post–Reformation, not Julian, style. Quite apart from his own actions and the reactions of others, Pope Julius styled himself "royal pontiff." To his followers on a military compaign he recited passages from the *Aeneid,* as if to remind them of his own imperial destiny, and to the world at large his spokesmen proclaimed his attributes as builder, liberator, peacemaker, provider, and legislator in imperial language and on an imperial scale.

Projected by Julius himself, reflected from the culture around him, these images were pieces of a picture which clearly informed Raphael's own. It would be fanciful to suspect armor under the display of red velvet and white silk on the London panel. But the bull neck, youthful hands, seemingly powerful arms and legs, ready to spring into action, might well have flattered any Renaissance prince and *generalissimo.* Whether in Erasmus's adjectives or more generously, the face portrayed, as we have already suggested, the reality and the mask of the "choleric" temperament—the temperament of leaders of men and of the god of war. Such a figure could be imagined as his own *condottiere,* the fortress builder who constructed or restored at least nine strongholds in the Papal States, the pope who pushed the boundaries of the territories of the Church to the farthest limits they had ever reached, or would ever reach again. Regal in life, and in Raphael's portrait, so too after death Julius was to have been placed in a tomb designed by Michelangelo (1505) in the free-standing form of tombs for northern royalty and their upstart imitators in Italy. We might well believe that the

subject of Raphael's *Julius* was determined, as he and others for him claimed, to liberate Italy as but the first step toward the conquest of the Holy Land and the unification of the world under his leadership. The themes were those of the Renaissance papacy; the pitch was wholly Julian.

Much in the London portrait quite specifically declared the likeness to be princely and regal. Or so it would seem if we allow iconographical significance to certain motifs we have already considered in purely formal terms. We saw in the first chapter not only that the obliquely seated figure and the background cloth of honor could be traced to traditions of French portraiture, but also that these motifs had been elaborated in depictions of royalty. Relatively informal in contrast to full pontifical or liturgical dress, even the ermine-trimmed cape and the cap—*mozzetta* and *camauro*—seem to go back to royal origins. These garments apparently evolved from the long, fur-trimmed robe and helmetlike hat which the popes first began to wear in the manner of French kings while resident at Avignon (Plate 24). Robes of similar type were worn with the tiara, symbol of the pope's temporal authority, by Eugenius IV at the middle of the fifteenth century (Plate 25), and secular princes in Italy were shown wearing them later in the Quattrocento. Sixtus IV adopted the shortened version of the robe and more bowl-shaped hat used later by his nephew (Plate 10), but it may be that the implication of royalty had not been lost. While modern eyes may still read the thronelike chair as royal furniture, contemporaries

probably saw much more of the "royal pontiff" in Raphael's *Julius*.

Raphael's apparent references to costume and forms which had figured in portraits of Sixtus IV were themselves a tribute to the dynastic thrust of princely rule in Renaissance Italy and elsewhere (Plates 9–10). The large, luminous acorns of the Della Rovere oak on the back of the papal chair were altogether explicit. They signalled, among other things, the closest approximation to genuine dynasticism possible in an institution whose head was elected at the instigation of the Holy Spirit. In a world of power politics where the available means commonly fell short of the ends proposed for government, a firmly established dynasty was looked upon as a source of continuity and some measure of effective control. The opportunities and obligations of the individual in the context of his household and lineage—a major concern of recent historians of Italian Renaissance society—were thus projected into the highest political arenas. Nepotism had particular attractions for a pope, faced with entrenched institutional structures and, very likely, with the hostile clients of his predecessor. Medieval commentators, not Renaissance apologists, had developed the stock excuses for those "who build Zion with the help of blood relations."

No previous pope had favored his nephews more lavishly, or shown his nepotism more conspicuously in art, than Sixtus IV (Plate 10). And no papal *nipote* stood by family traditions or, despite disclaimers from Pastor, exercised his own position as family

head more completely than Julius II. The testimony is overwhelming that he viewed himself as the loyal nephew of Pope Sixtus and a faithful member, however humble its origins, of the Della Rovere clan from the Ligurian town of Savona. Inscriptions proclaimed the dynast everywhere: on Julian medals, coins, manuscripts, fresco cycles, and buildings. Paris de'Grassis concluded that Julius sought "in many, almost in all things, to imitate his uncle Sixtus." The London panel was true to form.

Not that Julius stopped at princely conceptions of his role. Neither his followers nor his enemies doubted that he possessed—or was possessed by—what a medal commemorating the submission of Bologna called "imperial virtues." His building projects alone would have sufficed for an emperor. There was Bramante's Belvedere—"eighty feet high and 1000 feet long," trumpeted an inscription. Comprising a new imperial palace and villa, with sculpture court, theater, garden, fountains, nymphaeum, and porticoed walkways which have been called a *via triumphalis,* the architectural ensemble boasted a scale and coherence unequalled since the Roman empire. Michelangelo's "royal" tomb was also imperial, recalling, as has been suggested recently, Pliny's account of the Mausoleum of Halicarnassus and imperial funeral pyres known from Roman coins which depicted rites acclaiming the emperors as gods. "I am certain," Michelangelo announced to his patron, "that if it is made, the whole world will not have its equal"; "in beauty and splendor," added Vasari,

"and in the grandeur of ornament and the richness of statues, [the 1505 design for the tomb] surpassed all ancient and imperial sepulchres." For his design of the new St. Peter's, Bramante is reported to have acknowledged his debts to the Basilica of Constantine and the Pantheon. But Sigismondo de'Conti, the pope's private secretary and historian, believed that the new church, too, was planned to surpass all its ancient prototypes. "By the inspiration of Vitruvius," exulted the papal protonotary and court poet Evangelista Capodiferro, "Ancus Marcius and Caesar Augustus were reborn in Julius." The imperial architect, an early founder of the city, and the builder of imperial Rome were to live again as one.

Inscriptions, poetry, and prose expanded the list of "imperial virtues" in elaborate epithets—Expulsor of Tyrants; Author of Peace; Custodian of Tranquillity; Restorer of Public Liberty; Defender of Justice; Recoverer of Justice, Peace, and Faith. Words were acted out in processions *all'antica.* Specific references were made, or implied, to identify Julius with some particular emperor, not only with his namesake or with Augustus but also with Tiberius, Trajan, and Constantine. The identification with Caesar was important for the Julian name and for the archetype of empire-building; the *pax romana* of Augustus had prepared for the *pax Christi,* the reign of Christ, born in the Augustan Age. Trajan had been wisely victorious, and by his conversion and supposed donation of the western empire and imperial regalia to the pope, Constantine had accomplished the union of the temporal authority of the Roman empire and the spiritual dominion of the Church—the *respublica*

christiana. Even in darker moments of recognition Julian Rome would not settle for less than the analogy between its pope and Tiberius.

The spell of Constantine was especially powerful. Believed to commemorate the providential victory over Maxentius which had led to the establishment of Christianity in the Roman empire, the Arch of Constantine had already appeared as a prominent symbol of papal supremacy in the frescos commissioned by Sixtus IV for the Sistine Chapel. For the triumphal Julian entry into Rome in 1507 a replica illustrating the pope's military exploits was erected directly in front of St. Peter's. Pope Julius was, in effect, the new Constantine. The following year Michelangelo envisaged the Sistine Chapel as a kind of triumphal arch for his ceiling frescos, the organization and structure of which have been shown to be a creative reordering of nearly all the component parts of the Arch of Constantine. Raphael's frescos for the *Stanza d'Eliodoro* quoted freely from the same source and, in one of the window embrasures, illustrated Constantine's donation to Pope Sylvester. Julius himself issued several coins inscribed with a cross and the prophetic words of the emperor's dream on the eve of his battle with Maxentius—*In hoc signo vinces*. Lorenzo Valla's famous treatise of 1440 proving that the Donation of Constantine was an early medieval forgery had obviously been discounted; or rather, reacted against with the insistence of challenged belief. In 1510 favor-seekers were still sending the pope their works on the Donation, including the text of the "original" in Greek.

But of course Julius had to outrank the ancient

emperors. "Never had any Caesar or any Roman commander" equalled him, declared one witness to the celebrations in April 1512 after the collapse of the French army so recently victorious. Giles of Viterbo could compare ancient emperors unfavorably with Julius, whose sway ran over the Old World *and* the New. Julius Caesar had depended on sheer military power, but Pope Julius, insisted Giles, drew on the power of piety. "The pope wants to be the lord and master of the world," reported the Venetian ambassador in 1510. As a Mantuan agent put it two years later, he was, at any rate, "a man capable of ruining a world."

Emperor in the imagination and in life, Julius was imperial too, as we could only expect him to be, on the London panel. We suggested earlier that Roman reliefs of seated emperors influenced the *form* of Raphael's Vatican fresco of Julius-as-Gregory-IX and the slightly later London likeness; but imperial *content* was hardly likely to have been unintended— or missed—in Julian Rome. One possible source, the Aurelian relief of *Liberalitas,* was assumed (because transferred to the Arch of Constantine) to represent Constantine distributing coins after his victory over Maxentius (Plate 7). It was the pose that Julius himself had imitated at Bologna in 1506, and in 1511–12 one especially charged with symbolic hope amidst the challenges to his authority. The other possible imperial source, the Vatican sarcophagus of an emperor crowned by a winged victory, was installed beneath the so-called Cleopatra in the Belvedere sculpture court just at the time Raphael was painting

the London panel (Plate 8). Julius Caesar and Augustus, both conquerors (and one a conquest) of the Egyptian queen, were obvious associations. This was precisely the kind of understanding a courtier set to verse: just as Julius Caesar, conqueror of the Nile, had loved Cleopatra, so too Pope Julius, "second only in time," symbolically loved Cleopatra and would be victorious by bringing her effigy into the Belvedere. It was known that Augustus had placed a golden likeness of Cleopatra in the Temple of Venus after his victory at Actium; so too could Pope Julius, another Augustus, bring her image to the sacred precinct of the Vatican in anticipation of victory. With Raphael's imperial sources, then, came the imperial allusions which could make his subject out to be a new emperor, confident of mastery, ruler of a universal empire over the West and the East.

Particular details in the portrait had the potential for reinforcing such allusions—even so innocent a prop as the cloth in Julius's right hand. In classical antiquity a cloth, or *mappa,* held in the hand had been a mark of status. As illustrated on Roman ivories, it was the particular insignia, when held in the right hand, of consular rank, a position often occupied by the emperor (Plate 26). By the mid-fifteenth century historians knew that Constantine had taken the consular title four times and that consular diptychs often showed the *mappa* in connection with scenes of *liberalitas.* Beyond these associations with imperial authority and with the kinds of formal sources Raphael may have used for his portrait, it was also understood that the great cycle of games marking

the beginning of the new year in the ancient calendar was opened by throwing down or lowering the *mappa*. Could there be some hint of renewal and regeneration, too, in the cloth of the London *Julius?*

If not the cloth, then certainly the dynastic acorns were standard equipment in Julian visions of universal renewal through imperial (and Della Rovere) dominion. The iconographical resources of those family totems grew as many-branched and as dense as the tree they represented. Consider the following stock of (to the Renaissance) commonplace associations:

—acorns as the food of the golden age in Arcadia;
—the holy oak which grew from the staff of Romulus on the Capitoline Hill, so to mark the *caput mundi;*
—the oak under which Venus gave armor made by Vulcan to Aeneas in a symbolic translation of imperial authority from the East to Rome;
—the oak as a symbol of the cardinal (and imperial) virtue of fortitude;
—the oak of the tree-of-life;
—and so of the Cross, which brought renewed life to the ends of the earth and time.

The image makers—and the iconoclasts—of the Julian world could hardly have been better provided for. The imagery of oak and acorns could be managed in vast productions of theme and variations always a little mysterious but never quite secret. The allegorical oak would have had to be created if it had not already existed.

Since it did exist, it was used to the fullest. Preachers and writers such as Giles of Viterbo,

Marco Vigerio, Girolamo Vida, and Pietro Bembo drew on its implications of a kind of Christian imperialism of renewal. Julian medals showed the Good Shepherd directing his flock from a large oak through the strait but triumphal gate into paradise. On the Sistine Ceiling garlands of oak and acorns were entwined in a message of salvation and redemption through the Church Universal. Sublime in Michelangelo, the empire of the oak was only ridiculous in papier-mâché and gilt pageantry. Or so it would have been, had these ceremonies, like all ceremonies, not been so fraught with the deeper intentions and the needs of their time and place. Even on a Julian scale it would be hard to conceive of a joke so colossal as Julius's entry into Orvieto (1506), where little boys hung as angel-acorns on the branches of an oak, exchanging praising choruses with a costumed Orpheus on the *piazza* below; or as the parade of 100 youths in Bologna, each with an acorn-tipped staff.

Nothing was spared in Rome. Here is a scene from Julius's entry, 27 March 1507, after his victorious campaign for the recovery of papal territory in northern Italy. Near the Castel Sant'Angelo stands a float, round in shape, drawn by four white horses. Ten youths are dancing with palms of victory—it is Palm Sunday; they sing to the glory of the divine Julius, *expulsori tyrannorum*. Above the dancers' heads the celestial sphere of universal dominion; above the sphere, between two palm trees, reaching higher than the church of Santa Maria in Traspontina, a golden oak filled with acorns. The inscription runs: "Under Julius the palm has grown up from the oak.

No wonder—for these are the works of Jove." On
what was believed to be the site of the supposed
tomb of Romulus the oak has risen over the very
foundations of Rome; the oak reigns over the youths
of a new generation, the globe, the inscription to the
head of the Roman pantheon, and even the palms of
Christ the King. In another scene, the oak appears
on the last car in the carnival procession of 1513. At
the top of the tree, within a circle of branches, there
is an effigy of the pope. Beneath it hang likenesses
of the signatories of the Holy League—Emperor
Maximilian, Ferdinand of Spain, Henry VIII of En-
gland. Swords are drawn for the defense of the
Church and the conquest of the Holy Land. The oak
is the symbolic scaffold of a papal utopia.

Julius's critics did not set their sights on the oak
because such spectacles were not taken seriously. Sa-
tire, as Burckhardt pointed out, was the obverse
side and antidote of Renaissance pretensions to fame.
Erasmus's St. Peter ostentatiously ignored the golden
oak. Others accepted the rules of the allegorical
game in order to overturn it. In the punch line of a
pasquinade of 1506, acorns were "little valued, now
that the golden age has passed." Jean Lemaire,
apologist of the schismatic cardinals at Pisa in 1511,
mocked a pope who "will not succeed in creating
the new and abnormal world he hopes for; for pigs
will always eat acorns, and oaks will shed their
leaves at the proper time, and where wood is
wanted, wood will be used." Clearly, the oak and
acorns were not a mere dynastic label, still less sim-
ply interior decoration. Followers and foes alike

might have agreed that the golden acorns in Raphael's *Julius* had much larger purposes than framing the head of the figure. With other trappings in the portrait they could also frame the princely and imperial callings of the pope in the expectation of triumphant renewal and universal dominion even at the brink of desperation and defeat.

Prince, king and emperor—Julius was all of these in the context of his culture, and his portrait. But in the most exalted visions of Julian Rome he also remained what his detractors have insisted, and even sympathetic observers have feared, he was not— high priest, Supreme Pastor, true believer. Raphael suggested as much. The attributes and the formal traditions in his portrait denoted the high priest of the Roman Church. The beard had what we have seen to be Old Testament, apostolic, and votive implications. And there was much else besides to confirm the sacred character of the likeness and of the panel itself.

Let us look again at a few details. Beneath the red cape the figure wears a flowing white dress, or rochet—a liturgical vestment. More than differences in climate or changes in fashion may have shortened the cape after the popes returned to Rome from Avignon. The abbreviated *mozzetta* worn by Sixtus IV, Pope Julius, and virtually all later popes uncovered more of the rochet; at a time when the popes were especially concerned to reaffirm the sacred character of their office perhaps this was deliberately meant to distinguish them from secular princes, who affected

the long robes of the French royal style. Removing the cape and donning the elaborately embroidered stole over the undergarment, the pope was dressed for the celebration of the Mass; with the heavy cope over the rochet and his high, pointed mitre he moved in sacred procession. Paris de'Grassis worried a great deal about keeping Pope Julius in appropriate dress. It was his business as master of ceremonies to do so because Renaissance audiences noticed such things, down to the tilt of a cap and the cut of a jerkin, a tabard, and—we may be sure—priestly attire.

For the same reason they probably attributed more than regal pretensions or merely ornamental show to the rings in Raphael's *Julius*. Certainly the rings were conspicuous for their number—all six of them—and for their impressive gems—diamonds, rubies, and emeralds, so far as we can tell. We know that there were many more treasures in the Julian hoard, including a laminated gold and silver ring carved with the four doctors of the Church, set with a diamond, and reportedly worth the enormous sum of 22,500 golden *scudi*. A memorable outburst of Julian *terribilità* ensued on the loss of a diamond, and Paris de'Grassis related how Julius commanded from his deathbed that he be buried wearing two precious rings. Despite the princely, not to say parvenu, touch, rings could have peculiarly clerical meanings quite apart from whatever happened to be carved on them. They had long been symbols of marriage and fidelity, a symbolic usage emphasized by the Church around 1500. The ring of a bishop sealed his own symbolic marriage to Christ and the Church, and

had a liturgical function, too, when held for the communicant to kiss during the Mass. Within a few months of Raphael's portrait the image of Pope Julius as the Bridegroom was to be much favored among those who spoke at the Fifth Lateran Council. Something of that image may well be preserved for us on the London panel. We cannot really be certain—but neither should we be so sure, as the satirists might have been, that his rings were simply one more mark of worldliness.

Popes were entitled, in fact, to wear at least three rings, and a book on protocol dating from 1516 ruled that they could wear as many as they wished. Which, if any, of the rings in the portrait may have been specifically papal is unclear. But it may be worth noting that the colors of the jewels shown on the right hand were, like those of the painting overall, colors prescribed for the theological virtues: white for faith, green for hope, red for the fire of charity. A few years earlier Raphael had arrayed the personification of Theology for the *Stanza della Segnatura* in those colors, and it is probable that symbolic meanings were intended for the London panel as well. Nor does this seem so far-fetched when we remember that color symbolism was fashionable enough for the sharp-tongued humanist critic Lorenzo Valla to make fun of it around the middle of the Quattrocento.

The possibility of multiple references to Julius's priestly role prompts another look at the cloth he holds in his hand in the portrait, for here too marriage symbolism and liturgical implications may

have been layered together with quite different
meanings. In more or less contemporary marriage
ceremonies the bride and groom could be united by
covering their joined right hands with a ritual cloth.
A so-called care-cloth was sometimes held by the
priest over the heads of a newly married couple as a
sign of their union. Judging from Botticelli's Villa
Lemmi frescos (c. 1484), where the figures hold
cloths in scenes which have been thought to com-
memorate a marriage, this kind of symbolism was
understood by artists and their audiences. The same
claim can be made with rather more confidence for
the quasi-liturgical meaning of purifying and
sanctifying the hands with a cloth. The silk band, or
maniple, on the forearm of a priest in liturgical dress
is known to have evolved from the ancient *mappa,*
and the general sense of purification and sanctifica-
tion clearly underlies the holding of a cloth in paint-
ings as distant from Raphael's as Giotto's *Stefaneschi
Altarpiece* in the Vatican (c. 1330) or as close as Bot-
ticelli's Uffizi *Adoration* (c. 1472–75) and Ghirlan-
daio's *Visitation* (1485–90) for Santa Maria Novella
in Florence. The cloth of the pope imperial, the cloth
of the Holy Bridegroom, held in what seems after all
a gesture of blessing—these were far from being im-
possible combinations in the Julian world.

When we turn from the portrait to the culture
around it, we find such combinations everywhere. If
Julius's name was imperial, it was pontifical as well.
In 1505 he issued a brief promoting the cult of his
other namesake, the first Pope Julius, the fourth-
century lawgiver and martyr whose relics had just

been recovered. In April 1510, reported the Venetian ambassador, the pope "went to S. Maria in Trastevere, where the body of Pope Julius is, and there performed certain ceremonies," and on 26 May he announced a plenary indulgence to all who visited the church. Again, if Julius entered Bologna like a triumphant emperor, dressed in purple, throwing coins to the crowds, he also appeared as bishop, wearing a mitre, with the Host carried before him. The coins he dispensed in imperial style included the image of St. Peter. On his return from Bologna to Rome in 1507 he passed through an arch bearing Caesar's own motto, "I came, I saw, I conquered," and the medal struck for the occasion was inscribed *Julius Caesar Pont[ifex] II* (Plate 27). But the medal showed Julius in a papal cope; the obverse carried the Della Rovere and the papal arms and the words "Blessed is he who comes in the name of the Lord" (Psalms 118:26) from the processional hymn for the Feast of the Tabernacle in the Mass of Palm Sunday, the day the pope, in imitation of Christ, chose to enter Rome. In the minuscule space of one single medal Julius could be at once emperor and pope, prince and priest.

In the greatest spaces of Julian Rome, Christian foundations and spiritual aims were not forgotten. "Let the profane keep out": this inscription near the entrance to the sculpture court in the Belvedere defined that space as holy ground. If so, it was of another religion, complained Gianfrancesco Pico, surveying the pagan gods and demigods assembled there; even the warning notice came from Virgil.

Nevertheless, in the allegorizing vein of long-standing traditions and of the Julian court, the *Apollo Belvedere* could be read as Christlike; Hercules wrestled with Antaeus, as Christ had struggled with sin and death; *Venus Felix* foreshadowed the Virgin and the Church, and *Laocoön,* as a contemporary poem made clear, the fate of those who resisted divine authority. Allegory was unnecessary in the case of the new St. Peter's. Pope Julius, already custodian of St. Peter's name and relics as cardinal of San Pietro in Vincoli, allowed St. Peter to come first. He would not permit Bramante to reorient the church at the risk of tampering with the apostle's tomb. And for all the kingly and imperial elements in the design for his own burial place, a crucial fact in its conception was that it was meant to stand close to the remains of the prince of the apostles. In the *Stanze* and the Sistine Chapel, too, the doctrinal and even sacramental lessons were probably of a far more conventional kind of Christianity than has usually been supposed.

Even that least credulous observer, Niccolò Machiavelli, concluded that Pope Julius "did everything to aggrandize the Church. . . ." Certainly the pope's position as Supreme Pastor and successor to St. Peter was not left to inscriptions and to art. Nothing infuriated him more than assaults on the "liberty of the Church," and no one who faced his tongue and his stick on this point doubted that he meant to vindicate the Church at all costs. Warrior cardinals, papal mercenaries, and, in Cesare Borgia, the son of a pope had been seen in the field before,

but never a pope in armor, rushing into the breach.
A crusade against the Turks had been promised by
every pontiff-elect since the early fifteenth century,
but no pope, with the exception of Pius II after
the fall of Constantinople in 1453, took his pledge
more seriously than Pope Julius. The threat was real
enough as Turkish pressure increased against Hun-
gary, Austria, and even the coasts of Italy, and so
was his response. Julius's fortifications at Ostia as
cardinal (1483) and at Civitavecchia as pope (1508)
were directed primarily against Ottoman attacks. In
1506 he ordered Giles of Viterbo to preach before
the cardinals that Constantinople and Jerusalem
would be liberated after the conquest of the Papal
States, and in 1507 he sent a cardinal-legate to pro-
mote the crusade at the court of Emperor Maximi-
lian. With the king of Portugal he looked to ventures
on land and sea in the Orient as part of a great
crusading effort. These projects were discussed to
the very end of the Julian Age—in sermons in the
Sistine Chapel and in Santa Maria del Popolo; in the
papal bull (25 July 1511) announcing the Fifth Late-
ran; in any number of diplomatic dispatches and re-
ports. The mission of conquest in the West and the
East had become no less apostolic than princely or
imperial.

The same could be said of papal administration in
the city of Rome and the Church at large. The pope's
menacing stick became "the sacred rod of justice" in
the eyes of one contemporary, who added that it had
always been used "to acquire and maintain the wel-
fare of the Holy Roman Church." Julius issued some

40 papal bulls, more than his three immediate pred-
ecessors combined. Reform of the religious orders
was a special preoccupation. Despite his own dubi-
ous election, strongly worded provisions against
simony were announced on at least two occasions. In
his presence and in the words read in his name at the
first session of the Lateran Council the desperate
need for reform was openly and eloquently recog-
nized. Julius appeared not as an emperor but as the
canonist-pope Gregory IX on the south wall of the
Stanza della Segnatura (Plate 6). A medal probably
struck in connection with his peace with his rebel-
lious Roman subjects in 1511 adopted the biblical
phrase "Justice and peace now embrace" (Psalms
85:10). The unfinished Palace of Justice which would
have consolidated judicial institutions on the pope's
model street, the new Via Giulia, was a project as
much in the spirit of an Old Testament priest and
king as of a Roman emperor. (Ever ready with an
analogy, Giles of Viterbo called Julius another Sol-
omon and David.) It may tell us something about
the importance of the holy lawgiver's role to the
pope that the building would have been second in
size only to the Belvedere and St. Peter's in the sa-
cred precincts of the Vatican.

In the milieu and in the subject of Raphael's por-
trait we have found worldly roles edging every-
where into spiritual ones. Classical forms carried
Christian convictions; images from mythology and
Scripture or from history, ancient and medieval,
figured and prefigured the unfolding of divine pur-

poses. This synthesizing kind of spirituality seems perfectly consistent with our suggestion that certain details shown on the London panel can be referred as much to the sacred as to the profane callings of the pope. So much so that we have only to go a little farther to suspect that the multi-levelled conception and, for want of a better word, the "mood" of the portrait rested in very fundamental ways on the religious outlook which seems to have prevailed in Julian circles.

One of the overriding characteristics of the faith articulated by preachers, theologians, and writers close to the pope was the ideal of continuity and unity in time and in type. Julian Rome and very often Pope Julius himself were understood to represent and to embody the holy cities and the divine messengers of the old and new dispensations. All roads did lead to Rome, the New Jerusalem, and all preordained roles to the pope, the new Adam; in the city and through God's vicar what had been established and gradually revealed from the beginning of time would be fulfilled. Cajetan, Master General of the Dominicans, opened the second session of the Lateran Council (May 1512) with such comparisons. But one did not need to be a theologian to grasp what was being heard and, as it seemed, enacted in Julian Rome. For those in Julian circles not to see, or not to pretend, that there were many divinely charged dimensions of identity in the pope was more difficult.

Julius himself brought much of his willful urgency to this all-embracing spiritual mission. On his

deathbed he spoke of his "martyrdom" as pope. According to one source, he had his reward, for "at his death he was adored as if he were a saint." Other reports added that he died "constant and strong toward God"; "with so much devotion and contrition that he seemed a saint"; as if his were "the true body of St. Peter." It is true that there is something of the canonical "good death"—of a pope in the final proof of piety or even of the old sinner saved in the nick of time—about these accounts. They convey something, too, of the religious aura inspired by power and good luck, especially in a Mediterranean culture used to associating the Hero and the Holy Man. On the other hand, the position of the pope and all his other *personae* hinged on his capacity to represent, channel, and use divine authority. Since doctrines that linked spirit and flesh were particularly important to validate the mystery of the pope's own powers, Julian piety and Julian art had good reason to feature such orthodox and mediating themes as the Incarnation, Transubstantiation, the Trinity, and the cult of the Virgin—vessel and symbol of revelation and the Church. To think of the *papa terribile* as a saint may offend nothing more than a quite peremptory squeamishness about the limits of what can be truly pious. What is certain is that in his piety, as in most things, Pope Julius was not one to be lukewarm or altogether conventional.

But the fervor of apocalyptic and millenarian zeal was another major current in Julian spirituality. Not only was history believed to have reached a fullness in Rome and in the pope; it was widely

expected in Julian circles that history would end there. Visions of that glorious new time to emerge from turmoil and tribulation at the end of the old time run deep in Western consciousness; how deep in Renaissance Italy recent studies have finally been able to show. A wave of acutely anxious and hopeful expectation peaked around the turn of the Quattrocento. The mood of hope and fear gripped the powerful and the lowly. We know that men of learning and quite orthodox religion were affected as intensely as the marginally learned or the heretics real and imagined.

The signs were closely watched in Julian Rome. For the great troubles always foreseen in prophetic visions Julian seers could point to the continuing scourge of the foreign invader, the horror of a new schism impending in the Church, the threat of the Turk; any number of moral offenses and doctrinal failings (especially the Aristotelian denial of the soul's immortality) were always easy for prophets to turn up and to magnify in Renaissance Italy. The official pronouncement read in Julius's own name at the opening of the Fifth Lateran Council acknowledged that "every institution has collapsed" and "a great upheaval of morals has occurred." On the other hand, positive signs of renewal seemed to be drawing nigh on an unheard-of scale. A plenitude of peoples, time, and doctrine—always a mark of the coming millennium—could be read into the voyages of discovery, the conquests of Pope Julius, and the Fifth Lateran Council, which together, it was believed, presaged the conversion of the en-

tire world and the return of the true faith to its
roots in the East. The days before the millennium
were supposed to witness battles to end all battles
against the Unbeliever—as perhaps, in the Great
Crusade preached under Pope Julius. In the flour-
ishing restoration of learning, literature, and art
Rome seemed to have become once more the *caput
mundi,* ready again for the mission millenarian
traditions had assigned to the Holy City even from
Etruscan times to the Julian Age. If there was to
be an angelic pope to lead the elect or an antipope
to resist them, his identity could hardly have been
in doubt.

The insistent themes of spiritual ripeness and
apocalyptic intensity found their most powerful ex-
pression in the great fresco cycles of Julian Rome.
Raphael's own frescos in the *Stanza della Segnatura*
(1508–11) united and integrated the major spokes-
men of wisdom from past to present in the continu-
ous quest for knowledge through reason, revelation,
poetic inspiration, and law. Their very presence in
what was evidently Julius's private library attested to
the return of a Golden Age of understanding deliv-
ered from the beginning of time to the Vatican and
the pope, who himself appeared in the guise of one,
probably two, of his greatest predecessors. On a
tremendous scale Michelangelo's Sistine Ceiling
(1508–12) began with the Creation and summarized
the history of mankind "before the Law" to form,
according to standard Christian chronology, a con-
tinuous sequence with the earlier Sistine frescos be-
neath illustrating the eras "under the Law of Moses"

and "under the Grace of Christ." Leading up to the
message of providential continuity, the lunettes and
spandrels depicted in alternating pairs the unbroken
lineage of Christ from Abraham to Joseph; above
them Old Testament prophets and pagan sybils saw
signs of salvation yet to come. The enormous panels
from the Book of Genesis in the center continued the
tale of the future in the story of the most distant
past. Man fell into original sin, death, and disgrace in
the *Temptation of Adam,* the *Flood,* and the *Drunken-
ness of Noah.* But there was hope in the Days of Cre-
ation and the visionary prophets and sybils. Many
references to water, wine, and redeeming acts of sac-
rifice and penance suggested the promise of salvation
through the sacraments. The presence of paired
couples, children, and greening garlands, hills, and
vines hinted everywhere at regeneration. The en-
emies of the true faith were undone on the accom-
panying medallions and pendentives, nowhere more
violently than in the pendentive figures painted in
1511–12. The commonplace association of Eve with
the Virgin and of the Virgin with the Church made
the *Creation of Eve* at the very center of the vault the
fulcrum of a salvific history: the institution of the
Church was already prefigured in the founding of
the human race.

Although completed in part after the death of
Pope Julius, the murals by Raphael for the *Stanza
d'Eliodoro* (1511–14) were the most explicit visual
machine of the Julian outlook. In the vault, Old Tes-
tament histories alluded to Christ's incarnation, sac-
rifice, redemption, and foundation of the Church;

scenes in *grisaille* were taken mostly from the Arch of Constantine, as if to link the divine plan with the Roman empire. The window embrasures showed Constantine and Pope Sylvester founding the *respublica christiana,* challenges to the authority of Christ, and the final challenge and triumph of the Apocalypse. The walls themselves began with the Old Testament (*Expulsion of Heliodorus from the Temple of Jerusalem*) and continued counterclockwise to the New Testament (*Liberation of St. Peter*), the Early Christian Era (*Repulse of Attila*), and the Middle Ages (*Miracle of the Mass of Bolsena*). In each case divine intervention came to the aid of priest or apostle, moving clockwise against the direction of "mere" human chronology. In each case the bearded Julius (or a surrogate) was a participant in the action or an observer. The panorama of time played itself out in and for the *papa terribile;* foreshadowing his aspirations, his trials, and his victories, history projected through him into the future. In Raphael's *Sistine Madonna* (c. 1512–13) Julius's apotheosis was complete (Plate 28).

We could continue in detail. The blend of late medieval, pro-papal, and (from Florentine circles) humanist versions of a rapidly approaching fullness of time pervaded Julian culture and Julian art. Clearly we are not dealing with two opposing outlooks—medieval prophecies of gloom versus Renaissance optimism hailing the new Golden Age. For many in Julian circles great tribulation and great beatitude seemed juxtaposed in history and in their own experience.

But we may already feel that we have somehow seen this perspective at work before. A sense of trial but of deep-seated faith in blessings soon to come would very nearly describe the characterization of Pope Julius by Raphael. Was there not a profound cultural and, ultimately, a profound religious resonance to the intense expectation *and* weary dejection we see in Raphael's *Julius?*

Erasmus would have none of this—or rather, his Renaissance dreams of renewal and his ideal Church were cast in another mold. In his Julian dialogue St. Peter countered every defense. Pope Julius protested that "the whole Christian state would collapse if it could not protect itself against the power of its enemies"; it would have been better, retorted St. Peter, if Christendom could see in its head "the true gifts of Christ—namely, holiness of life, sacred learning, burning love, prophecy, virtues. . . . " Julius spoke of enlarging, adorning, defending the greatness of the Church; St. Peter of "earthly sway," "destructive wars," runaway pleasures, extravagance, vice. If Julius was so mighty, challenged the saint, let him take his gang of men and hoarded wealth to build a new paradise. There was little room for compromise—perhaps there still is not. *Tout comprendre, c'est tout pardonner* has probably never been a very true or possible principle.

What we can suggest, and see in the papal roles reflected in Raphael's portrait, is the pressure of historical circumstances and aspirations. Over the long term the popes responded to a deteriorating political

and economic situation for the Church by taking a princely part in the affairs of Italy. They drew support from late medieval and Renaissance theories of papal monarchy and from the political example, the legal structure and the lore of imperial Rome. The sense of continuity from the Roman empire not only legitimized papal claims to universal sovereignty and plenitude of power; it also ensured that, as the recovery of the literary and artistic remains of antiquity accelerated, the propaganda campaign waged in defense of the papacy would be increasingly clothed in the form and imbued with much of the spirit of imperial Rome. But the spiritual authority and sacred mystique of the Roman Church and the papal institution, newly charged with millenarian zeal, were never far from the roles assumed by Renaissance popes. At few moments could the stakes have seemed higher or the pope's mission as prince, emperor, and high priest more compelling than in 1511–12. Not the least of the miracles of the Julian age was that Raphael and Pope Julius undertook their portrait encounter in that fullness of time.

3

The Setting and Functions of a Renaissance Portrait

We first hear of what must have been the London panel when, early in September 1513, a portrait of Pope Julius was displayed for eight days on the altar of Santa Maria del Popolo (Plate 29). The Venetian ambassador who is our source tells us that the pope had commissioned the likeness sometime before his death eight months earlier and had given it to the church of the Augustinian friars. There the ambassador left it, as art historians have by and large been content to do. But the church of Santa Maria del Popolo was not neutral wallspace, simply one church among the 300-odd churches of Renaissance Rome lucky enough to receive a random gift from the pope. Many of the deepest concerns of Pope Julius and his age led to and from the Popolo. In its physical fabric and in its significance the church became a Julian temple, sanctuary, showcase, and theater. To preserve, museums deprive art of its original setting and function. To confirm and extend what Raphael's *Julius* has already let us see in the Julian world, we must try to restore it to the place it has lost.

Between 1506 and 1512, Pope Julius came to Santa
Maria del Popolo on several notable occasions. His
first campaign for the recovery of papal territories as
far north as Bologna was launched there on 26 Au-
gust 1506, and there the victorious expedition ended
on the vigil of his Palm Sunday procession to the
Vatican, 27 March 1507. Four years later (26 June
1511) the bearded Julius reentered Rome at the
Popolo from his second campaign in the north,
this time defeated by the French and deprived of
Bologna. The Virgin (it was thought) had delivered
him from a cannon shot, a near miss, on the front
lines at Mirandola, and in her church at the gates of
Rome Julius offered prayers in which downcast pas-
sion and expectant faith must have been mixed—as
they seem to be in the closely contemporary London
portrait.

Two key maneuvers in his strategy for revenge
brought the pope to the church again during the fol-
lowing months. On 5 October 1511 the Popolo re-
sounded with the solemn proclamation of the Holy
League which united Julius, Ferdinand of Spain, the
Venetians, and, a few weeks later, Henry VIII of En-
gland against the French. Then, after the surprise re-
treat of a winning but shattered French army from
Ravenna, the virtual collapse of the French-inspired
Council at Pisa, and the sacrifice of the emperor's
Venetian enemies to papal *Realpolitik,* the church
served to stage the ceremonial adhesion of the Em-
peror Maximilian to the League on 25 November
1512. In the time between the great public spectacles
we know that, early in September 1508, Julius ap-

peared in the Popolo as a grieving and tearful pilgrim to appeal for the recovery of his favorite nephew Galeotto della Rovere from what turned out to be a fatal illness. During the same general period the pope must have come as patron to inspect Bramante's new choir (c. 1505–10), with its ensemble of tombs, frescos, stained glass, and, eventually, the *Madonna of the Veil* and his own portrait by Raphael.

While Pope Julius drew on Santa Maria del Popolo at the high points of his reign and the low, from public ceremonies to private devotions, the Popolo drew from him in turn the impulses we have come to expect in his presence. Certainly the individualism we have seen before was on full display there. The diary of his master of ceremonies was a perfect foil. Paris de'Grassis, with his hovering valet's eye, was quite sure to note good form and equally certain to grumble if Julius chose to have his own way. When the pope broke with convention, it was sometimes because, in life as in art, the nature of the case and good sense required it. For example, he would have preferred Matthäus Lang, the imperial ambassador on whom so much depended in November 1512, to accept the proper dignity and attire of a cardinal— Lang's reward for the emperor's adherence to the League. But the ambassador, self-important like his master, and wanting to be wooed, arrived at the Popolo in his ordinary bishop's robes. How could he possibly be seated among the assembled cardinals, wondered the harassed master of ceremonies? "Why not!" demanded the pope, and there, over the pro-

tests of Messer Paris and offended dignitaries, the af-
fair of the ambassador's new clothes ended. At other
moments Julius remade ritual in the Popolo because
it was his prerogative to do so. His entourage could
only murmur in consternation on the eve of Palm
Sunday 1507 when he saw fit to bless not the cross
but the altar of the Virgin—where his portrait would
be placed. Again, he could order the church deco-
rated with fronds of palm and olive branches to suit
the occasion or, in November 1512, adapt the liturgy
so that prayers would be said for the Holy Spirit, for
himself, and for the emperor. He could be the model
pilgrim at the Popolo nevertheless, distributing alms
to the friars, humbly petitioning their prayers for his
nephew. These actions will not seem out of character
in the subject of Raphael's *Julius*.

At Santa Maria del Popolo, too, the particular, and
particularly mixed, roles of a Renaissance pope were
intensely exposed. A princely Julius arrived at the
church for his Palm Sunday vigil of 1507 as Raphael
would show him, in *mozzetta* and *rocchetto*. Only
when a stole replaced the red cape at the church door
was it quite clear that he was a priest; to the obvious
relief of his master of ceremonies the *Te Deum
Laudamus* could then be sung within. The next day
the pope heard Palm Sunday Mass before proceeding
in triumph to St. Peter's. Palm fronds and olive
branches filled the church; Bramante's romanizing
choir was rising at the end of Sixtus IV's nave, one
of the prototypes for which was the Basilica of
Maxentius and Constantine—the presumed "Temple
of Peace" commemorating the Emperor Vespasian's

victory over Jerusalem. Through recollections of Jerusalem and imperial Rome, the church became a symbolic sign and seat of the union of both divinely chosen cities in the greater empire of Christ and His vicar. The long-standing Della Rovere connection and the family's monuments hinted in no uncertain terms at dynastic claims to this inheritance. It comes as no surprise that Julius's Palm Sunday procession to the Vatican fused the reenactment of Christ's entry into Jerusalem with the pageantry of an emperor's triumph in Rome.

But there was also room for the pious priest in Pope Julius at the Popolo, particularly for his devotion to the Virgin. It was the Virgin's altar that he blessed in March 1507, and it was to her he turned to heal his nephew (Plates 29–30). In June 1511, no matter how late the hour or how dispirited the papal party, Julius paused to kiss the cross at the door to the church and offer prayers at the altar before retiring for the night. Against this background, much about the portrait Raphael was soon to paint suddenly comes clear in ways that will need to be considered in some detail. It may suffice for now to point out that the week of early September 1513 when the portrait appeared on the altar was the octave of the Nativity of the Virgin. The old devotee had thus returned, "as if he were alive," to witness and to share the reverence due his great protectress.

Julius made what was probably his last appearance in the flesh at Santa Maria del Popolo on 25 November 1512 to celebrate the reception of the emperor into the Holy League. The ceremony was

the occasion for Giles of Viterbo's valedictory to the Julian Age. Fifty-two diplomatic envoys and fifteen cardinals, including the obstinate imperial ambassador, filled Bramante's choir to the right and the left of the pope and in front of the altar. The Augustinian general introduced his theme: in the hour of darkest calamities yet had God worked a great liberation of his Church. Schism had raised its serpent's head at Pisa; the massed forces of the League had been overwhelmed at Ravenna by the basilisk of war, and Rome itself had trembled in the fear that God had abandoned His people. In this very night before Creation, this gloom of unenlightened souls to which the Platonists and St. John the Evangelist bore witness, only "Julius Pontifex Maximus, with all the firmness of his [oak] tree, never ceased to bear his burden, never gave in. He, following the example of Almighty God, whose place he occupies, said 'Let there be light. . . . ' " The calling of the Lateran Council was like the light of Creation on the First Day; the condemnation of the schismatic Pisan council took the place of the creation of the sky and the separation of the waters on the Second Day. The Third Day brought forth the fruits of the earth as the third session of the council produced the first harvest of a Church trusting to the power of its sanctity. To Rome, in the Holy City, the message was proclaimed: *fugit impius nemine persequente.* Now, as at the midpoint of Creation when the sun was made, the Holy League had gathered in the temple of the Mother of the Greatest Son, and the work of reform and renewal would beam from the Lateran Council with His light.

Near the end of his oration Giles turned to Julius himself. The pope and the emperor had joined to bring about a New Age of unity and peace, but there could be no mistake about the location of supreme authority, and the last word:

All men have seen you choosing nothing if not great deeds, acting against the unjust, the robbers, the tyrants, constructing eternal edifices, raising up the admirable mass of the temple, adding to the Holy See so much territory, so many peoples, so many splendid cities. And although these things might seem altogether great in themselves, how much greater still are those gifts which Almighty God has this year granted to you to overwhelm those two monsters which, striking out among peoples, had almost brought Italy and the Church to perish— Schism, I say, and War. . . .

O new day! O longed for day—never before seen by our ancestors, as never to be believed by posterity and its children! Who, I ask, does not see that God has never given any other Pontiff such deeds to perform as to you?

Such phrases, among the last Pope Julius was to hear in Santa Maria del Popolo, might well have been spoken of his portrait in the church. Light contrasted with the dark, despair close to deliverance, authoritative traditions adapted creatively to the present, a pope made out to be the special object and the summation of divine Providence once and for all time—the words of Giles and brush of Raphael worked strikingly similar effects.

The particular suspended moment of Raphael's *Julius* had passed before Giles began to speak, but not the character of the pope, the perspective of his culture, and the stimulus of his special church.

But why the special attachment to Santa Maria del Popolo? We know enough by now about the retrospective sweep of Julian culture to be sure that the answer must begin far back in the history of Rome.

At the base of the Pincian Hill, near the Flaminian Gate at the northern edge of the city, the site of Santa Maria del Popolo was steeped in memories of imperial Rome. These traditions had become, if anything, more vivid and more compelling in the course of the Quattrocento. It was not so much the medieval myth maker as the Renaissance antiquarian who transmitted tales of the Emperor Nero buried in the vineyard where the altar of the church was to stand; or the more historical picture of candidates for imperial office passing the site in white robes on their ritual descent from the Pincio. Renaissance accounts continued, too, the kind of exorcism which, in medieval legends, had turned such ground to Christian and specifically papal purposes. When medieval Rome receded to cluster close-knit around the River Tiber, the site was left a rural outpost, guarding the gate, marking boundaries, channeling the passage between the city and the world. It was territory which had to be resettled physically and reclaimed spiritually by the people and the bishop of Rome.

The name and the early history of the church reflected this dual reclamation. *Popolo* derived most likely from the term (*pieve* or *plebs*) for rural parish churches staking out Christian space in areas unsettled or adjacent to older civic centers in the early Middle Ages. But the legends of the place were no

less revealing. One tradition related the naming of the church to an appeal by the Roman people that the pope rid the site of the demons molesting settlers near and travellers through the Flaminian Gate. Then, there was the association with a nearby poplar tree or grove, the *pioppo,* which became in the fullest elaboration of the legend a sinister nut tree growing from the bones of Nero. In 1099, according to a fifteenth-century text, the Romans went to Paschal II seeking relief from these afflictions. The pope prayed with all his clergy to God and the Blessed Virgin. On the third night the Virgin appeared to him, commanding that the tree be cut down and a church to her honor be founded in its place—which in grand procession and ceremonies at the spot was done to the dismay of the Enemy. Pope Paschal raised with his own hands an altar to the Virgin; he endowed it with indulgences and relics, among them relics of the Virgin and St. Sixtus (and so of the chief saints of Sixtus IV and Julius II). In the thirteenth century, the account continued, Gregory IX (again the pope whose part Julius took in Raphael's *Segnatura* fresco; Plate 6) brought to the place one of those miracle-working icons supposedly painted by St. Luke. The Virgin of the Popolo (Plate 30) continued to work her Julian miracles nearly 300 years later, the power of her church enhanced by relics of her dress, veil, hair, and milk.

By the fifteenth century, on the strength of much legend and a little history, Santa Maria del Popolo was a link to traditions of the empire, the people, and the bishops of Rome, a gatehouse to the material

and the spiritual city, a junction point of Marian
majesty and miracles. To these attributes Sixtus IV
and the Della Rovere set about making claims for
themselves in the manner of the restoration-minded
culture of Renaissance Rome. So much the better
that the medieval church-with-cloister seems, in con-
trast to the site, to have been undistinguished. It
suited the stylish new magnificence of the upstart
clan of Ligurians to borrow prestige without en-
cumbrances. Between about 1472 and 1480 Pope
Sixtus rebuilt the church from the foundations
up—or at any rate altogether transformed it.

Among his motives there is no reason to doubt that
the Virgin came first. We would expect as much
from the old Franciscan whose mother had told of
dreams of Mary summoning him to the Order (Plate
31). Francesco della Rovere had made much of his
reputation as a polished theologian in writings on
the Immaculate Conception; as pope, he granted
privileges to the cult of the Virgin at the Popolo—
two of them were inscribed on either side of the
principal entrance—and built other churches and al-
tars for her. "Moved by piety and the singular devo-
tion he had always toward the Blessed Virgin he
erected from the foundation the church of Santa
Maria del Popolo"—the original inscription on a
fresco celebrating the building of the church made
the Marian motive quite explicit (Plate 32). Other
motives could not have been far behind for the papal
monarch, dynast, and self-styled *Restaurator Urbis*.
The family needed, in effect, their pantheon,

mausoleum, and royal chapel, where their piety might be treasured up in this life and for the next. If Rome was to see new days as *caput mundi* under the Della Rovere, then the Via Flaminia and Santa Maria del Popolo were a necessary artery and northern lobe. This was the route of pilgrims, supplies, and the expected reconquest of papal territory. With overtones of rising millenarian expectancy, another commemorative inscription suggested that pious works such as building the Popolo also "prepared the way for the kingdom of Heaven."

Buildings are often deceptive, but Renaissance ap-plications of the supposedly modern principle that "form follows function" may not be at all irrelevant at Santa Maria del Popolo. The Sistine church, much obscured by later additions, was a three-aisled, vaulted basilica in the form of a Latin cross, with an octagonal drum and cupola at the crossing and polygonal chapels extending off the side aisles (Figs. 1–4). For a family reliquary and mausoleum Sixtus could not have done better than to commission the side chapels, the first in Renaissance Rome to be de-signed as an integral part of the structure. Before the end of the first Della Rovere pontificate three mem-bers of the family occupied the chapels under monuments built in the best instant classicism of the Roman funerary style. Perhaps the half octagons of the chapels and the full octagon of the cupola-bearing drum over the crossing were employed to convey the traditional association of the eight-sided figure with the eight days of Christ's passion and

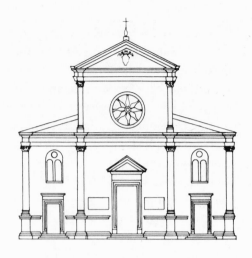

1. Rome, Santa Maria del Popolo. Facade, c. 1477.

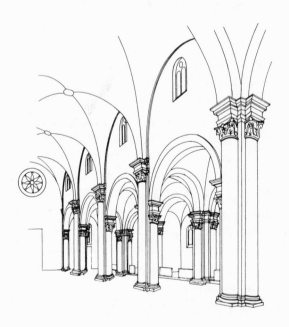

2. The Sistine Nave, c. 1472–80.

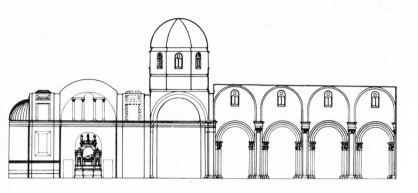

3. Section of Santa Maria del Popolo as it appeared in the reign of Julius II.

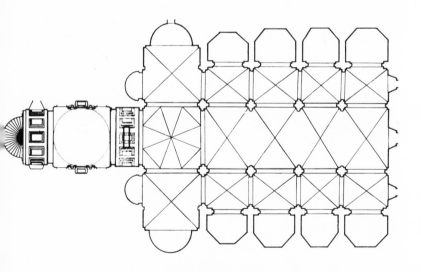

4. Plan of the Sistine Church with the Julian additions of c. 1505–10.

5. Rome, Santa Maria del Popolo. The Julian Choir, 1505–10.

resurrection. Domes were a standard architectural metaphor for the vault of heaven, where Della Rovere dead surely expected their reward. Symbolically or not, the dome of the Popolo, the first of the Renaissance in Rome and the first glimpse of the city for travellers from the north, was obviously calculated to impress. So was the pure (and purloined) Roman articulation of the interior. Augustinian churches in Lombardy probably influenced the plan, but in Della Rovere hands the church became a

monument to the New Rome, the Virgin, and themselves.

In 1509, Francesco Albertini's new Roman guidebook saluted Pope Julius in phrases which fairly describe his own apparent intentions at Santa Maria del Popolo: "Sixtus IV began the restoration of the City, his successors followed in his footsteps, but your Holiness has outstripped them all." Julius was very much the good *nipote* when, around 1505, he began where his uncle had left off—at the choir. The dating and sequence of the additions and extensions to the choir are not altogether certain between the general dates 1505 and 1510. We are not sure to what extent the project evolved by steps or was conceived as a totality by Bramante, Julius's premier architect and chief artistic adviser during this period. What is clear, and consistent with Della Rovere traditions, is that Julius concentrated on the area of the Virgin's altar and the rites performed in her honor. Julian patronage also developed the Roveresque concern for the funerary function of the church and, as Sixtus had done at the Popolo and elsewhere, brought together a team of the best artists available for the undertaking. It was as much the family as the Julian manner, too, for the outcome to fuse a classicizing style and vocabulary with conservative Christian symbolism and iconography.

Bramante's project moved from a barrel-vaulted space off the crossing to a square mausoleum area before ending in the choir proper, with its own coffered barrel vault and scallop-shell apse (Figs. 3–5).

The first barrel vault contained the Virgin's altar, behind which, under the second vault, Julius apparently sat for the ceremonies of November 1512. Between the vaults, the mausoleum was designed with the central plan and geometrical harmony equivalent to divine perfection and eternity in Renaissance architectural theory. Two facing tombs were commissioned for the niches of this center section (Plates 33–34). Here Julius buried his nephew and adopted son Cardinal Girolamo Basso della Rovere (d. 1507) and, with a gesture of magnanimity and political calculation, an old enemy, Cardinal Ascanio Sforza (d. 1505). Sforza support from Milan was an important consideration in any papal strategy in northern Italy, but Julius could afford to be magnanimous, since Cardinal Ascanio, who had provided for the church shortly before his death, died intestate, so that the pope was entitled to his inheritance in accordance with canon law.

For the Julian building campaign, too, despite recent arguments for earlier origins, Bramante seems to have constructed a low-hanging sail vault over the altar in order to create more prominent space for frescos by Pinturicchio. Whether included in the original design or added as a brilliant afterthought, three-part windows *all'antica* were used to penetrate the wallspace between vault and tombs and light the ensemble. The choir itself occupied a rectangular space of its own, yet provided tombs and altar with an appropriate visual and functional backdrop. The barrel vaults, with their Pantheonlike coffering, established a triumphal and specifically Roman pas-

sageway to the great scallop shell of the apse, with its classical and early Christian allusions to redemption and eternal life.

These themes were fully elaborated in the more or less traditional and predominantly Marian iconography of the tombs, windows, and vault. In the central lunettes over the tombs, the Virgin and Child mediated between God the Father and the reclining effigies surrounded by personifications of the cardinal and theological virtues (Plates 33–34). Placed as if to intercede for the dead cardinals by reason of the attributes figuratively claimed for them, Mary was represented as the model of their love and substituted, in fact, for the otherwise missing virtue of charity; she was also the symbolic object of their love and, again, the channel of grace between heaven and earth. All the other elements of the tombs expressed a similar conjunction, or transition, between the material and spiritual worlds. The effigies seemed to hover between life and death. Used in funerary contexts since antiquity, the shells, the flaming candelabra, and the swags and vines bore witness to the triumph of death—but also to the anticipation of immortality, light, and renewed life. Decorated with angels and cherubim, the arched forms of the tombs designated the way of release from terrestrial existence and the triumphal entrance into paradise. Even the bold signature of the sculptor centered on each tomb boasted of earthly skill in a bid for eternal fame.

Links between spirit and flesh were likewise the traditional message of the episodes from the lives of

the Virgin and of Christ narrated in the stained glass windows (Plates 35–36). The narrative unfolded in two rows arranged in chronological sequence from left to right. The top band of the Virgin cycle—*The Meeting at the Golden Gate, The Birth of the Virgin, The Presentation of the Virgin*—illustrated the birth and sanctification of Mary as the instrument of divine love. Incarnation was the theme of the lower band—*The Marriage of the Virgin, The Annunciation, The Visitation of the Virgin and St. Elizabeth*. In the Christ cycle of the window opposite, all three of the upper scenes referred to the Nativity, while the incidents beneath prefigured the essential aspects of Christ's redemptive purpose. Christ was first consecrated in the *Presentation in the Temple; Christ among the Doctors* marked the beginning of his teaching and preaching mission. The central episode, *The Flight into Egypt,* was understood in standard exegesis to foreshadow Christ's sacrifice and ultimate salvation. Needless to say, the patron did not conceal his contribution or implied connection to the glittering lesson in light. The coat of arms, the oak, and the name of Pope Julius appeared prominently in both windows.

On the vault the sybils painted by Pinturicchio revealed their prophecies (Plate 37). The accompanying inscriptions told of the incarnation and redemption foreseen long before the Advent: "The invisible Word will become known"; "The offspring of the Virgin will be the salvation of mankind"; "The Son of God will become flesh and judge the world"; "In the last age God will become man." The four sybils were combined with the four evangelists, who were

complemented in turn by the four Latin doctors of the Church—Ambrose, Jerome, Augustine, and Gregory. The message of salvation, ordained from the beginning and valid for all time, could thus be seen in its passage through the pagan mysteries, the revealed truth of the gospels, and the authoritative interpretation of the Church Fathers. At the center of the vault the *Coronation of the Virgin* showed the resolution of the distance between spirit and flesh when the human creature became divine.

Marian and family space, a self-conscious adaptation of antiquity to Christian uses—the requirements of the good nephew were well met at the Popolo. Concern for precedent extended into matters of detail. The new choir seems, for example, to extend and complete the interior of the Quattrocento church, for a massive apse and tripartite Serlian windows figured in Renaissance renderings of the "Temple of Peace" quite as much as in structural features appearing in the Sistine nave. The new tombs echoed the style of the earlier tombs. The octagonal aperture for the *Coronation of the Virgin* at the center of Pinturicchio's frescos on the sail vault repeated the shape of drum and cupola over the crossing, and the artist of the vault was the painter of the decoration in the family chapels.

But the dutiful heir followed precedent only so far. The scale and style of the choir showed up the Sistine church for its rather halting classicism. In important respects the new choir did not even need the old church. The Julian additions could be perceived as virtually self-sufficient through any number of

formal devices—the closed symmetry of the two tombs sharing the cardinal virtues and linked by the orientation of the effigies to the apse; the repetition of a tripartite structure in the tombs, the high altar, and the windows; the diagonal turn of the fresco layout to join the burial spaces; the self-referencing response of the niches of the four doctors of the Church frescoed in the vault to the niches of altar, tomb, and apse; the reappearance of the four doctors on the altar and the vault. St. Luke shown on the vault painting an image of the Virgin implied a link to the actual icon on the altar beneath. Balance, rhythmic variation, and subtle modulations of tone unified and animated the overall composition. The symbolic content reflected the liturgical functions of altar and choir in the themes of death, sacrifice, salvation, and immortality.

Building on and yet out from tradition, then, new standards were set in the choir. Bramante's architecture was a pace-setting essay in the evocation of antique space and form. Testing Renaissance conceptions of universally authoritative principles of design, his work became a scale model of many elements in the choir for the new St. Peter's. Sansovino's development of basic Florentine prototypes became the norm in funerary monuments for the rest of the century. In the final design (1542–45) for the tomb of Pope Julius himself the new motif of the half-reclining effigy poised ambiguously between life and death was adopted by Michelangelo. Marcillat's stained glass introduced French standards of excellence in a medium which had been little known in

Rome. Raphael and his followers departed from Pinturicchio's archaeological reconstruction of Roman ceiling decoration. The impressive integration of media—architecture, sculpture, and painting— looked forward to Raphael's Chigi Chapel in the Popolo and far beyond it to the Baroque.

We can now return to Raphael's *Julius* with a very full sense of its setting in time and space. The portrait dates from the period between the completion of Pope Julius's new choir at Santa Maria del Popolo and his culminating appearance there, for God and the Holy League, on 25 November 1512. The painting signalled, accordingly, the end of commitments beginning early in his reign and, still earlier, in the generation before him; it signalled, too, the beginning of the end of the Julian Age. More than merely marking time, however, Raphael's *Julius* was marked in turn by much of what was believed and enacted in the physical and chronological space to which it once belonged. As Raphael made him out to be, so Julius often was, or seemed, in his special church. What remains to be suggested is that the relationship between portrait and setting was not a passive connection; that the portrait, if it was acted upon, was also an actor with supporting roles to play. For like the places for which they were made, Renaissance portraits had functions to perform.

It is true that we do not really know where Raphael's portrait hung. Our closest reference puts the papal likeness and gift on the altar for the Feast of the Nativity of the Virgin shortly after the death

of the pope. That is all—just enough to imply that
the position was temporary. At least for the high
holiday of the Nativity we can picture the image at
the place of honor on the Virgin's right, which is to
say, somewhere to the left of the icon in the center
of the altar (Plates 29–30). The next references, from
the 1540s and later, seem to confirm the occasional
hanging for feast days, now on a pillar, apparently
paired opposite Raphael's *Madonna of the Veil* (Plate
3). We could wish, as patron and painter might well
have done, for a still more Julian location. At the
center of Bramante's apse, under the shell-shaped
symbol of immortality, the portrait would have been
highly visible on axis with the altar. Like Julius him-
self in November 1512, his image would have pre-
sided over prayers from the apse and would have
been situated to receive them; it would also have
been ideally lighted by windows on the upper right,
as if by design, the *only* apsidal windows. In the
empty wreath now at the crown of the apse a Julian
insignia could have labelled the subject of the picture
and the builder of the choir. The fit seems perfect.
Unfortunately, it also seems quite unlikely, since
the migration to the altar for feast days would hardly
have been necessary with the portrait already in so
central and conspicuous a position. Other papal por-
traits are known to have hung in sacristies, and we
are left, however reluctantly, to imagine Raphael's
Julius hanging in the sacristy of the Popolo on all but
special occasions.

Still, the brief appearance on the altar had its Julian
touch. So far as we know, it was unprecedented to

locate such a portrait on an altar. Or rather, this was
still another Julian (and Raphaelesque) leap from
precedents and purposes which conditioned the
meaning of the commission.

A patron was entitled to be noticed before his
works. In *his* choir, in *his* family's favorite church,
Julius took his place in Raphael's portrait as patron
and donor. The portrait reinforced coats of arms and
inscriptions; it put the face of the individual and his
roles on what was to be seen unmistakably as a Ju-
lian enterprise. Small wonder that we found our-
selves tracing formal sources for Raphael's work to
representations of donor types—Renaissance popes,
French kings, Roman emperors, and Sixtus IV. Here
again Renaissance form was probably following Re-
naissance function. With a difference, however. In
the portrait at the Popolo the donor and the artist
emerged on their own. Sponsoring saints have been
dismissed; the donor, no longer reduced to appear-
ing in profile, commanded the picture space. The ob-
ject of the donation was outside, not within, the pic-
ture frame, and the portrait could be valued in itself
and for its value as art.

Even so, Julius did not come to the Popolo simply
as a high-spending and rather possessive patron of
art; he came there as the special patron and client of
the Virgin. Donor portraits sprang from the desire
for salvation and the rather more tangible benefits
expected from pious works, and there is every rea-
son to believe that Raphael's *Julius* was no exception.
Julius had put himself under the Virgin's care in
painting before. As cardinal, he knelt before the Vir-

gin in the right wing of a provincial altarpiece
painted before 1484 by Giovanni Mazone (Plates
38–39). He was his uncle's creature, sharing the
hometown chapel of Sixtus IV in the Cathedral of
Savona. It was Sixtus's patron saints, Francis and
Anthony, who were shown, and it was Sixtus who
took the honorary place at Mary's right, receiving
the Christ Child's benediction and monopolizing the
light. The conventional kneeling posture and rela-
tively small scale of the donor in a sacred presence
remained in another Savona polyptych by Vicenzo
Foppa, dated August 1490 (Plate 40). But Cardinal
Giuliano moved from joint to sole patron and
petitioner, from his uncle's chapel to the high altar,
from the wings into the central panel with Virgin
and Child. The place of honor and the light were
now his; advanced by his own angel, he alone re-
ceived the attention and the benediction of Christ. In
effect (and as usual), Raphael simultaneously con-
tinued and went beyond the cues of tradition on the
London panel. In the church of the Virgin of the
Popolo and on her altar the likeness must have been
seen as the portrait of her donor and devotee, mag-
nified now in proportion and significance by the
papal office and Raphael's skill.

Raphael's portrait must have been, in fact, nothing
less than a votive image, one of a series of interlock-
ing Julian offerings and acknowledgments to the
Virgin culminating only with Raphael's *Sistine
Madonna* (c. 1512; Plate 28). In 1473 the sculptor
Andrea Bregno completed the so-called Borgia Altar-
piece to encase the miraculous icon at the Popolo

(Plate 29). The evidence for a Borgia commission is problematic, because it rests on the inconclusive testimony of much later documents and a pair of Borgia arms on a base which appears to have been added to the altar. It is at least as likely that the future Pope Julius may have begun to do his duty by the Virgin of the Popolo (and she by him) at the very outset of his career in Rome. Sixtus IV was just beginning his building campaign at the church in 1473—one year after the Virgin was believed to have interceded to halt an outbreak of plague and little more than a year after naming his nephew Giuliano a cardinal. The circumstances would have been right for a Della Rovere and a Julian gift to the altar. It is clear that the future pope made some sort of early claim on the miracle-working altar near the Flaminian Gate. For at the top of Bregno's work we find the coat of arms of none other than Cardinal Giuliano della Rovere.

Subsequent Julian transactions with the Virgin usually came back to the Popolo. As if in gratitude for his victories in the north, Pope Julius gave pontifical sanction in 1507 to the shrine of Loreto; in the same year he founded the church of Santa Maria di Loreto near Trajan's column in Rome. The Della Rovere had already revived the cult and opened accounts on the legend of the little town in the Marches where the house of the Virgin had miraculously appeared in the thirteenth century, delivered intact from the Holy Land. The Carmelites had been called to the spot by Cardinal Girolamo Basso della Rovere, bishop of nearby Recanati. Cardinal Girolamo had also received the dedication (1489) of

the official account of the miracle; in 1500 he had
completed the church Sixtus IV had begun to build
around the Holy House. It was this same Della Ro-
vere nephew and adopted son whom Julius buried
beneath the Marian iconography of Sansovino's
tomb and Marcillat's stained glass in the choir of the
Popolo (Plates 34–35). And it was Bramante, ar-
chitect of the still unfinished choirs at the Popolo
and St. Peter's—both dedicated to the Virgin—to
whom the pope entrusted both his plans for the
newly founded church in Rome and his wish "to do
great things" at Loreto.

The interchange between Rome and Loreto con-
tinued. As the project at the Popolo neared comple-
tion, work at Loreto began in earnest. New privileges
for the *Lauretana* were published in March 1509; later
that year a medal was issued with Bramante's design
for a new facade on one side and a profile of the
donor, *Iulius Ligurus Pontifex Maximus,* on the other.
Soon afterward, at the time of his second expedition
in northern Italy, Julius was alternately increasing
and drawing upon his credit with the Virgin in
Loreto and in Rome. Before marching north, he
made the long detour to the Marches. Celebrating
the Nativity of the Virgin in the church of the Holy
House, he gave the shrine a silver cross, a chalice,
and a special indulgence. On his return in June 1511,
again by way of Loreto, he hung on a silver chain
over the altar the cannon shot he believed the Virgin
had deflected at Mirandola. Then, as we have seen,
he carried his prayers to the Popolo in Rome. One
can easily imagine the bearded Julius intoning the

prayers attributed to him for the Queen of Heaven and Mercy.

This brings us just to the edge of the period between June 1511 and March 1512 when Raphael evidently painted the London panel. In June 1511 the pope had offered his gifts at Loreto *voti et devotionis causa;* in August he took the nourishment that brought him through his nearly fatal illness "out of love for the Madonna of Loreto." In December 1511 he gave a portrait of himself to San Marcello, a Roman church of the Servants of Mary, or Servites, "because of a vow made to an image of Our Lady." The obvious inference is that Julius also meant, "because of a vow," to add a portrait by Raphael to his offerings at one of the most important and familiar seats of the Virgin in Rome, to place himself by that famous "image of Our Lady" in which he had so much at stake. And since there is no further evidence to connect Raphael with San Marcello or to suggest any tradition of independent portraiture of Julius other than that stemming from the painter's work at the Popolo, the San Marcello likeness (apparently burned in a fire of 1519) was probably one of many copies after Raphael. If so, the Popolo's original must have been finished by December 1511.

Something of this tale is told, after all, by the portrait itself. The beard as a sign of mourning and of appeal, the expression of reflection and readiness— the features we have tried to characterize so often would take on a far more exact meaning as a specific offering for grace recently received and still urgently needed. Even the immediacy of the likeness would

have been demanded in a votive image. To a Marian church such as the Annunziata in Florence thousands of lifelike effigies in wax and paint were presented at the altar by the humble and the great, including Sixtus IV. From no less a patron than Isabella Gonzaga or critic than Vasari we know that these likenesses were prized when "natural and so well made that they represent not men of wax, but life itself." There was no room for mistaken identities where such serious interests were concerned. In a votive setting, too, we can understand more clearly why Raphael's *Julius* appeared on the Virgin's altar, perhaps even why the portrait seems intentionally to respond to the presence of the icon. The oblique arrangement of the figure and the direction of light from the right side suggest as much; so do similarities in the disposition of head and torso, the linearity of fabric and hem, the counterpoint of closed and open hands, the rings (cf. Plates 2 and 30).

Starting from conventions in the imagery of dedication and donation, then, the pope and his painter defined a special relationship and a new equality with the Virgin and *her* painter. In the *Sistine Madonna* Julius knelt as an interceding St. Sixtus before the Virgin, finally occupying the same celestial space, as if sanctified by her dazzling display of power and special favor. It would be one more anticipation of this ultimate triumph over life through art if, as has sometimes been supposed, the *Julius* was meant to complement Raphael's slightly earlier *Madonna of the Veil* (c. 1508–9; Plate 3). The two paintings were very nearly the same size; they were strongly vertical in composition. The figures in each were

obliquely turned as if to one another, and were lighted from the right and the left as if to be hung flanking the high altar and illuminated from the central dome. Both works were set off by a green background cloth; closed, cloth-holding right hands and open left hands figured in each. The eyes were similarly downcast, the expressions contemplative. We cannot tell whether the Child wakes or sleeps, whether the veil is a coverlet or shroud; we do not know whether Julius awaits deliverance or death in his portrait. These connections can be made on grounds of formal and iconographical relationships, similar date, identical place, and the documentary evidence of at least a later pairing from the 1540s onward. It is the functional logic of an encounter of patron and protectress, vicar and vessel of divinity, which supplies a missing motive.

Until Raphael's *Julius* was discovered to be by the hand of the master himself, it was relegated to the storerooms of the National Gallery. Now it hangs in a place of honor, an object of aesthetic devotion. In its own time and place the portrait was, as we have seen, much more than a work of art. Yet it was an object of devotion—of a Renaissance kind. In three-quarter length the image of the pope can be imagined whole only by the willing beholder. At Santa Maria del Popolo, beholder and worshipper merged in the crowd which, after the death of the *papa terribile,* admired his likeness "as if he were alive" and adored him "as if he were a saint." The very accessibility of Raphael's *Julius* must have mirrored its special setting and function.

Epilogue

The Julian Image and High Renaissance Culture in Rome

In order to understand the making of a masterpiece, a scholar in a tale by Jorge Luis Borges tried to re-write *Don Quixote* as if it had never been written, word for word. Anyone who has looked at all seri-ously at Raphael's *Julius* since its restoration ten years ago to something like its original brilliance will understand the fascination of the attempt, and why it must have failed.

A work of art is obviously something greater and other than the sum of its parts. For all their analyses, the wisemen of Hindustan, "to learning much in-clined," still failed to see the elephant. The levels of our Renaissance likeness remain distinctions of anal-ysis and of language, not those the eye or the artist would necessarily have made. We would dispense with them if we could. But of course we cannot. It does not matter how good our vision may be. We need analytical distinctions to differentiate and bring into focus what might otherwise remain indistinct or be altogether missed; we also need them because, in its actuality and immediacy, the making of a work of art is no more recoverable than the living experience

of Pope Julius and Raphael. But we should not be satisfied with accepting bits and pieces in lieu of something whole. What we must try to do is see our portrait and our levels in the round, to consider how distinctions might be pieced together again. Although we cannot recreate the larger context of an original reality, we can create a larger context of interpretation. This is a fundamental task—and dilemma—of cultural history.

It is some help that we have been dealing with a work and a culture in which synthesis was a characteristic quality and often a quite deliberate aim. This synthetic aspect has taken many different forms at many different points in the preceding pages. Already at the outset we found that the individualism of Raphael's *Julius* was inclusive and integrating, not an exclusive or isolating trait. In formal and quite technical ways we saw that the painter seems to have drawn together motifs from various traditions of portraiture. Visually, the individualism of Raphael's work was synthetic twice over—a fusion of portrait types and an exercise of inventiveness on (and beyond) the available stock of precedents. Contemporaries who understood this in Raphael confirmed our own impressions and gave them a cultural rationale.

There were different emphases, but it was generally agreed, on the one hand, that true creativity was imitative and, on the other hand, that truly creative spirits would surpass received standards and respond to the unique challenges of nature and experience.

The creative process was a precarious balance between ideal and actual, convention and contingency, past and present. Extended to the reading of individual character, this view of things meant that any given individual was likely to be perceived not only as a particular person but also as an approximation to type. Physiognomical theory and practice reflected and encouraged this sort of double vision. So did prevailing philosophical and theological doctrines—for example, the conception made official at the Fifth Lateran Council that everyone possessed an individual soul which transcended nevertheless, by reason of its immortality, any particular temporal condition. Together with the intellectual justifications, the synthesizing thrust in Julian culture and in Raphael's portrait was sustained by the ideological and practical needs of the Renaissance papacy, developments in the practice of art and the premium that patrons were increasingly prepared to pay for artistic achievement. In this environment the best talent, the most advanced techniques, and the widest possible range of traditions could come together in Rome for what contemporaries themselves regarded as a fullness of time.

Looking to what we called the papal "roles" represented in Raphael's *Julius* or to the setting and function of his portrait at Santa Maria del Popolo, we saw this capacity for combinations everywhere. Julian culture was unwilling, or unable, to draw sharp distinctions where we would insist on them. Since the boundaries between sacred and profane, spirit and flesh, Christian and pagan were often blurred at best, it was perfectly

possible for the pope to play prince, emperor, and priest. Conversely, since the pope did play a composite part, it was perfectly possible and even necessary for such lines to remain indistinct. Whether they liked it or not, contemporaries had come to expect as much of a pope. The staging, the masks, the language of this mixed identity had developed deep in the traditions and the history of the papal institution; Renaissance popes had learned to mobilize and so to exaggerate every possible defense in reaction to the challenges against papal authority during the fourteenth and fifteenth centuries. It was not so much the roles as the sweep, the intensity, and the extravagance of the performance that must have impressed Raphael not least among the contemporaries of Julius II. By returning his portrait of the pope to Santa Maria del Popolo we were able to locate that impression in a place and time where it was thoroughly and purposively exposed.

Of course all cultures and their artifacts are to some extent synthetic. It is a second quality in Julian culture which makes the characterization especially apt—the consciousness and actuality of a kind of cultural culmination in Julian Rome. Culmination does not necessarily mean conclusion; if it were a matter of endings, a better case might be made for the death of Leo X in 1521, the sack of Rome in 1527, or the years after midcentury when one can begin to speak of a Counter Reformation and eventually a Baroque Rome. What the term does suggest well enough is the sense of cultural fulfillment, of arrival, of accomplishments long since anticipated and finally reached. We have seen something like culmination in this sense in

Raphael's weaving together of different portrait styles at a level of integration and equilibrium that neither he nor any other Renaissance painter had ever achieved before. We saw, too, that this technical feat was accompanied and surely conditioned in turn by a fully mature awareness of some of its basic presuppositions. There was nothing new about the doctrine of imitation, the psychology, at once deductive and experimental, of physiognomical teachings, or the definition of man as creature and creator in the image of God. But these Renaissance commonplaces had never been articulated more completely, shared more widely, or used more actively than they were in Julian Rome.

The "real" world did not, for once, lag far behind. The revival of Rome and the papal Counter Revolution beginning early in the fifteenth century came to a head in the policies and power, if also in the vulnerability, of Julius's pontificate. The high standing and heady opportunities of the creative élite in Julian Rome brought Quattrocento possibilities to a new pitch. No wonder Julian culture dreamed of the greatest heights and depths in its myths of itself.

Synthesis and culmination . . . both are familiar but extremely problematic terms for characterizing High Renaissance culture. They imply conceptions of development and criteria of judgment as old as Vasari, or even as the Roman author Pliny, from whom Renaissance writers learned most about tracing the history of art and of culture more generally. In his *Lives,* Vasari interpreted what he was the first to call the *Rinascita* of the arts in Italy as a process

of cumulative improvement handed down from one generation to the next. First in the Trecento, then in a second age during the Quattrocento, Italian artists had broken through the "darkness" and "decay" of the Middle Ages to the achievements of the Ancients. But the masters of the first two ages were only forerunners of still greater things to come from the third age of Leonardo, Raphael, and Michelangelo. "If [the former] were not altogether perfect," Vasari wrote, "they came so near the truth, that the third category . . . profited by the light they shed, and attained the summit of perfection. . . ." Studied reproduction of nature, proportion and design, lessons recovered from the best examples of ancient art—the results of two centuries of development were harmonized in the grand manner of the geniuses of the third age and elevated to such heights that "decline must now be feared rather than any further progress expected." The language has been changed, or only toned down and refined. The process no longer seems so clear or continuous or the outcome obviously authoritative. But at least for the first two High Renaissance or classical decades of the Cinquecento the Vasarian paradigm has survived more or less intact.

The problem with the traditional framework is not that it is *déjà vu*. The terrible verdict of a nineteenth-century reviewer—"What's true is not new; what's new is not true"—has lost none of its point in a time when the latest fad is only too likely to count for wisdom. If anything, like fashions old enough to become interesting again, the notion of a

Renaissance synthesis and culmination may even seem quite fresh and provocative. It challenges a modern loss of sympathy and touch with the formally balanced harmonies of rule and representation in classicizing traditions of Western culture. We no longer really care about the specific formal types developed in classical Greece and Rome and elaborated by generations of *epigoni*. The classics have become an excuse for nostalgia, or a subject for specialists, "archaeologists" in a general sense. We would no longer know a barbarian if we saw one. More than tastes have changed. It is the view of reality implicit in a classical style—ostensibly confident, orderly, and authoritative—which is profoundly at odds with whatever is restless, relativistic, and science-struck in the modern temper.

But the pride of place long enjoyed by High Renaissance culture and art has been undermined in quite specific ways. Art historians these days would hardly dare to dismiss Quattrocento artists as Pre-Raphaelites or Italian Primitives. Historians for their part have tended to push back the date of the greatest vitality and creativity in the Italian Renaissance to an ever earlier period. As a result, the picture of a society living off capital, losing its nerve, increasingly static and hollow by the later fifteenth century stands in the way of the trajectory toward perfection that once seemed so inevitable and so clear. And where the older view simply shrugged off or found enlightened benevolence in the authoritarian impulses of the later Renaissance, some historians have been inclined to limit the true flowering

of the Renaissance spirit to what they regard as the relatively pluralistic and dynamic republican cultures of Florence and Venice. The aftermath of the High Renaissance has assumed a different aspect too. Both Vasari's sense of continuity and the once-fashionable charge of decadence after Raphael have given way, for example, to a general revaluation of Mannerism as an experimental and expressive style, or a series of styles, with close affinities to modern movements in the arts. One common impulse behind these shifts of outlook may be a belated, almost a vindictive, recognition that the Renaissance has lost its traditional historiographical standing as the origin and Heroic Age of the modern world.

We are probably better for the loss. It forces us to look again and calls for a renewed sense of inquiry where few questions used to be asked or needed. The old assumptions of virtually inevitable progress to a determined end can certainly go unlamented. As the case of Raphael's portrait should suggest, it is the contingency and complexity of a cultural artifact that make it historically rich and revealing. We can also dispense with the secular orientation, the academic taste, and the high-minded idealism so often characteristic of the grand tradition of criticism. Had we supposed that the Julian world was rather unmindful of traditional religion or altogether committed to a new view of man as the measure of all things, we might have missed the intensity of conventional, even archaic, religious content and purposes in Raphael's work and the culture in which it was made. The assumption that the world of the painter and

his patron aimed at a pure classicism or under-
standing of antiquity would have been equally mis-
leading. Eclecticism and allegorical representations
of Christian content in secular or classical dress were
not shortcomings but essential features and, indeed,
accomplishments of Julian culture. And then, the
view that art exists "for art's sake" could only dis-
tort or diminish the significance of Julian art. That
art belongs to a self-sufficient and higher realm be-
yond mundane interests, that it is somehow valuable
in proportion to its uselessness, is open to question
in most periods of history. Raphael's *Julius* was
hardly pedestrian for having what were clearly prac-
tical functions to perform.

But after qualifications have been made, we are
still left with the themes of synthesis and culmina-
tion. Here, if anywhere, we may be close to seeing
the elephant after all. We do seem to be able to piece
together many patterns in Julian culture under those
rubrics; they give the evidence recognizable shape
and form. There may be more to this than fitting the
phenomena. In the end the traditional themes lead us to
a still more general proposition they expose and share.

If there was one central ideal in the culture of Julian
Rome, it was that culture was a kind of epiphany, a
"showing forth" in particular forms of the precepts,
ultimately of the divine principles, which particular
things were taken to exemplify. Something like this
understanding of culture made synthesis a possible,
even a necessary, cultural aim in the sense that it po-
sited appropriate categories by which experience
should continually be subsumed and measured. In-

sofar as experience was necessary to the categorical display and the measurement in the first place, it was in history and tradition that the principles behind (and in) all creation would be more or less fully revealed. One sought in history accordingly culminations in one time of what could be and had been, and one charted the course of history in terms of progress toward or decline from those Golden Ages when the ideal and the real were thought to be fully one.

Other corollaries to the notion of culture-as-epiphany have become familiar in these pages. The analogical and allegorizing modes of expression we have so often encountered were a likely consequence of seeing revelations of type in the existence of detail. When appearances must always be referred to categories that contain them, the world we perceive, or as perceived for us in texts and artifacts handed down over time, becomes an arena of similitudes, of signs corresponding to and resembling the deep-seated structures they are taken to indicate. As in the sixteenth-century *episteme* reconstructed by the French philosopher-historian Michel Foucault, so in Julian Rome "to know must therefore be to interpret: to find a way from the visible mark to that which is being said by it and which, without that mark, would lie like unspoken speech, dormant within things." If God had revealed and guaranteed the principles in nature and in history, to interpret had also to be to divine, to seek in the past, present, and future the innermost and most universal dimensions of spiritual meaning through the transparency of all creation. It followed that to interpret was to value and arrange things in an ideal order

according to their apparent truth to type. As reflections of divine realities, which were constant, types did not change. But since they might be neglected or obscured, closeness to their original form and Originator became an index of degrees of perfection and height of place among the works of this world. The great object of human inquiry in theory and in practice was to activate the archetype.

If all this may seem remote and abstract, its implications were anything but that. Translated into conviction, expressed in action, this cluster of assumptions incited the creative imagination, called for demonstrations from the leaders of men, and even projected an image of governance ideal for the human community. Hidden truths and underlying principles of significance were neither true nor significant for men until they were brought to the surface and made known. Since the visible world was a house of mirrors, of signs relating and related to what they signified, the imaginative faculty became the human instrument most suited to the need to make meaning manifest. It was for his ability to make symbols and to appropriate them in nature and his own activity that man was most like God. The power of the imagination was such that it could supersede and actually substitute for external reality. Improving on the data of experience from nature or the historical record, the image had in this sense magic enough to become the world as it ought to be. Representation *of* reality edged into representation *as* reality. At the extremes of this process, as Northrop Frye has put it, "a stupid and indifferent nature is no

longer the container of human society, but is contained by that society and must rain or shine at the pleasure of man." The creative imagination could not be less than what we have found it to be in Julian Rome—"apocalyptic," always at the edge of some revelation which had to be spoken out or shown beyond the sum of nature and of tradition.

Where imagination was knowledge and power, politics could not be far behind. More than a special virtue, patronage of art and literature became an obligation of leadership. Patronage validated a ruler's claims to further the best interests and to use the material resources of the community at his disposal. It connected him with the highest purposes and products of the human condition. His services were amply rewarded, to be sure. The leader became the subject and hero of the imagination, not simply because he had paid for it, but also because the mirroring of precept in particular guise which structured all creation could be identified and focused in him. For his power, for the encyclopedia of virtues and antecedents embodied in him, he occupied, as Giles of Viterbo said of Pope Julius in 1512, the place of God on earth.

In Frye's terms a "high mimetic mode" grants the ruler "authority, passions, and powers of expression far greater than ours," while subjecting him, like the heroes of epic and tragedy, if not of myth or romance, to the expectations of his society and the order of nature. The high mimetic has its central theme—"the theme of cynosure or centripetal gaze, which . . . seems to have something about it of the

court gazing upon its sovereign, the court-room gaz-
ing upon the orator, or the audience gazing upon the
actor." In Julian Rome that contemplation soared
highest in the vision of an earthly utopia as universal
and triumphant as its faith in the conjunction of
spirit and flesh. At least in the massive centering op-
eration of a classical style the Julian world could
deny the ambiguities of its own existence.

Pope Julius riveted the gaze of his contemporaries.
His *terribilità* gave a real presence to the mysterious
energies radiating through the particular things of
this world. He activated the archetypes of the institu-
tion and the city he represented and ruled. In him the
old prescriptions and prophecies that there would be
"one flock and one shepherd" when Christ would
"draw all things" to Himself seemed to spring to
life. At times, however brief, the mirrors of his cul-
ture, and Raphael's, became windows.

References

GUIDE TO ABBREVIATED TITLES

Ademollo A. Ademollo. *Alessandro VI, Giulio II, e Leone X nel Carnevale di Roma, Documenti inediti (1499-1520)*. Rome, 1967.

Albertini F. Albertini. *Opusculum de Mirabilibus novae urbis Romae*. Edited by A. Schmarsow. Heilbron, 1886. Also in *Five Early Guides to Rome and Florence*. Edited by Peter Murray. Farnborough, England, 1972.

Angelis P. de Angelis. *L'Ospedale di Santo Spirito in Saxia*. 2 vols. Rome, 1960 and 1962.

Bentivoglio and Valtieri E. Bentivoglio and S. Valtieri. *Santa Maria del Popolo*. Rome, 1976.

Bernardi A. Bernardi. *Cronache Forlivesi, Monumenti istorici pertinenti alle provincie della Romagna*. Ser. 3, *Cronache* (R. Deputazione di Storia Patria). Bologna, 1897.

Brummer H. Brummer. *The Statue Court in the Vatican Belvedere*. Stockholm Studies in the History of Art 20. Stockholm, 1970.

Bruschi A. Bruschi. *Bramante architetto*. Bari, 1969.

Buchowiecki W. Buchowiecki. *Handbuch der Kirchen Roms*. 3 vols. Rome, 1967-74.

Chevalier U. Chevalier. *Notre-Dame de Lorette*. Paris, 1906.

Cian V. Cian. Review of L. Pastor, *Geschichte der Päpste seit dem Ausgang des Mittelalters,* 3. Freiburg, 1895. In *Giornale storico della letteratura italiana* 29 (1897), 403-52.

Conti Sigismondo dei Conti. *Le storie de' suoi tempi dal 1475 al 1510.* 2 vols. Rome, 1883.

Di Cesare M. Di Cesare. *Vida's Christiad and Vergilian Epic.* New York, 1964.

Dussler L. Dussler. *Raphael.* London, 1971.

Erasmus *The "Julius exclusus" of Erasmus.* Translated by P. Pascal. Introduction and notes by J. Sowards. Bloomington, 1968.

Ettlinger L. Ettlinger. *The Sistine Chapel before Michelangelo.* Oxford, 1965.

Frommel C. Frommel. "Die Peterskirche unter Papst Julius II im Licht Neuer Dokumente." *Römische Jahrbuch für Kunstgeschichte* 16 (1976), 59–136.
 ————. "'Capella Iulia': Die Grabkapelle Papst Julius II in Neu-St. Peter." *Zeitschrift für Kunstgeschichte* 40 (1977), 26-62.

Gilbert C. Gilbert. *Complete Poems and Selected Letters of Michelangelo.* Edited by R. Linscott. New York, 1963.

Golzio V. Golzio. *Raffaello nei documenti, nelle testimonianze dei contemporanei e nella letteratura del suo secolo.* Vatican, 1936.

Gombrich E. Gombrich. "Hypnerotomachiana." *Journal of the Warburg and Courtauld Institutes* 14 (1951), 119–25.

Gozzadini	G. Gozzadini. "Di alcuni avvenimenti in Bologna e nell'Emilia dal 1506 al 1511. . . ." *Atti e memorie della R. Deputazione di Storia Patria per le Provincie di Romagna,* ser. 3, VII (1889), 161-267.
Grassis	Paris de'Grassis. *Le due spedizioni militari di Giulio II.* Edited by L. Frati. Bologna, 1886.
Grassis (Döllinger)	J. Döllinger. *Beiträge zur Politischen, Kirchlichen und Cultur-Geschichte.* Vienna, 1882 (reprinted Frankfurt, 1967).
Guicciardini	F. Guicciardini. *Storia d'Italia.* Edited by S. Menchi. 2 vols. Turin, 1971.
Hartt	F. Hartt. *"Lignum vitae in medio paradisi:* The Stanza d'Eliodoro and the Sistine Ceiling." *Art Bulletin* 32 (1950), 115-45, 181-218.
Hill	G. Hill. *A Corpus of Italian Medals of the Renaissance before Cellini.* 2 vols. London, 1930.
Huelsen	C. Huelsen. *Le Chiese di Roma nel Medio Evo.* Florence, 1927.
King	A. King. *Liturgy of the Roman Church.* London, 1957.
Klaczko	J. Klaczko. *Rome in the Renaissance: Pontificate of Julius II.* New York, 1903.
Legg	J. Legg. *Ecclesiological Essays.* London, 1905.
Lotz	W. Lotz. *Studies in Italian Renaissance Architecture.* Cambridge, Mass., 1977.

Luzio A. Luzio. "Federico Gonzaga ostaggio alla
 corte di Giulio II." *Archivio della R. Società
 Romana di Storia Patria* 9 (1886), 509-82.
 ———. "Isabella d'Este e Giulio II (1503-
 1505)." *Rivista d'Italia* 12 (1909), 837-76.
 ———. "Isabella d'Este di fronte a Giulio
 II negli ultimi tre anni del suo pontificato."
 Archivio storico lombardo 17 (1912), 244-334,
 and 18 (1912), 55-144, 393-456.
 ———. *Le letture dantesche di Giulio II e di
 Bramante.* Genova, 1928.

Machiavelli N. Machiavelli. *The Chief Works and
 Others.* Translated by A. Gilbert. 3 vols.
 Durham, N.C., 1965.

Miniature del *Miniature del Rinascimento.* Quinto Cen-
Rinascimento tenario della Biblioteca Vaticana. Vatican,
 1950.

Minnich N. Minnich. "Concepts of Reform Pro-
 posed at the Fifth Lateran Council." *Ar-
 chivum historiae pontificiae* 7 (1969), 163-251.
 ———. "The Participants at the Fifth Lat-
 eran Council." *Archivum historiae pontificiae*
 12 (1974), 157-206.

Moroni G. Moroni. *Dizionario di erudizione storico-
 ecclesiastica da S. Pietro ai nostri giorni.* 103
 vols. Venice, 1840-61.

Norris H. Norris. *Church Vestments: Their Origin
 and Development.* New York, 1950.

Oberhuber K. Oberhuber. "Raphael and the State
 Portrait—I: The Portrait of Julius II." *Bur-
 lington Magazine* 113 (1971), 124-30.

O'Malley J. O'Malley. "Man's Dignity, God's Love,
 and the Destiny of Rome: A Text of Giles

of Viterbo." *Viator* 3 (1962), 389-416.

———. "Giles of Viterbo: A Sixteenth-Century Text on Doctrinal Development." *Traditio* 20 (1966), 445-50.

———. "Giles of Viterbo: A Reformer's Thought on Renaissance Rome." *Renaissance Quarterly* 20 (1967), 1-11.

———. "Historical Thought and the Reform Crisis of the Early Sixteenth Century." *Theological Studies* 28 (1967), 531-48.

———. *Giles of Viterbo on Church and Reform: A Study in Renaissance Thought.* Leiden, 1968.

———. "Fulfillment of the Christian Golden Age under Pope Julius II: Text of a Discourse of Giles of Viterbo, 1507." *Traditio* 25 (1969), 265-338.

———. "Erasmus and Luther: Continuity and Discontinuity as Key to Their Conflict." *Sixteenth Century Journal* 5 (1974), 47-65.

———. "Preaching for the Popes." *The Pursuit of Holiness in Late Medieval and Renaissance Religion.* Edited by C. Trinkaus and H. Oberman. Leiden, 1974, pp. 408-40.

———. "The Discovery of America and Reform Thought at the Papal Court in the Early Cinquecento." *First Images of America: The Impact of the New World on the Old.* Edited by F. Chiappelli. Berkeley, 1976, pp. 185-200.

———. "The Vatican Library and the School of Athens: A Text of Battista Casali, 1508." *The Journal of Medieval and Renaissance Studies* 7 (1977), 271–87.

Pastor L. von Pastor, *Storia dei papi dalla fine del medio evo,* 16 vols. Rome, 1943–63.

Pauly– A. Pauly and G. Wissowa, *Real-encyclopädie*
Wissowa *der classischen Altertumswissenschaft.* Berlin, 1894–1963.

Pope– J. Pope-Hennessey. *Italian High Renaissance*
Hennessey *and Baroque Sculpture.* 3 vols. London, 1963.

 ———. *Italian Renaissance Sculpture.* 2nd ed. London, 1971.

Rodocanachi E. Rodocanachi. *Histoire de Rome, Le Pontificat de Jules II.* Paris, 1928.

Sanuto *I Diarii di Marino Sanuto.* 58 vols. Edited by F. Stefani, G. Berchet, N. Barozzi, and M. Allegri. Venice, 1879–1903.

Steinmann E. Steinmann. *Die Sixtinische Kapelle.* 2 vols. Munich, 1901 and 1905.

Tedallini Sebastiano di Branca Tedallini. *Diario romano.* Edited by P. Piccolomini. *Rerum italicarum scriptores,* N.S., XXIII, Pt. 3. Città di Castello, 1907.

Tomei P. Tomei. *L'architettura a Roma nel Quattrocento.* Rome, 1942.

Valla *The Treatise of Lorenzo Valla on the Donation of Constantine.* Translated and edited by C. Coleman. New Haven, 1922.

Vasari *Le vite de' più eccellenti pittori, scultori, ed architettori scritte da Giorgio Vasari.* Edited by G. Milanesi. 1568 ed. Florence, 1878–85.

Weisbach W. Weisbach. *Trionfi.* Berlin, 1919.

Weiss R. Weiss. *The Medals of Pope Sixtus IV (1471-1484)*. Rome, 1961.

———. "The Medals of Pope Julius II (1503-1513)." *Journal of the Warburg and Courtauld Institutes* 28 (1965), 163-82.

PREFACE

Art and History

M. Baxandall, *Painting and Experience in Fifteenth-Century Italy* (Oxford, 1972); P. Burke, *Culture and Society in Renaissance Italy, 1420–1540* (London, 1972), 3–21; E. Castelnuovo, "Per una storia sociale dell'arte," *Paragone* 27, no. 313 (1976), 3-30 and 28, no. 323 (1977), 3-34; C. Geertz, "Art as a Cultural System," *Modern Language Notes* 91 (1976), 1473-99; S. Alpers, "Is Art History?" *Daedalus* (Summer 1977), 1-13.

1. RAPHAEL'S *JULIUS* AND RENAISSANCE INDIVIDUALISM

Raphael's Julius

Sixteenth-century notices: Sanuto XVII, 60; *Il codice magliabechiano,* ed. C. Frey (Berlin, 1892), 128; Vasari IV, 338 (for the 1550 edition see H. Grimm, *Das Leben Raphaels* [Berlin, 1886], 133–34); R. Borghini, *Il Riposo* (Florence, 1584), 388-89; G. P. Lomazzo, *Idea del tempio della pittura* (Milan, 1590), 132.

Modern studies: C. Gould, *Raphael's Portrait of Pope Julius II: The Re-emergence of the Original* (London, 1970); *idem,* "The Raphael Portrait of Julius II: Problems of Versions and Variants; and a Goose that Turned into a Swan," *Apollo* 9, (1970), 187–89; Oberhuber, 124–30; Dussler, 29–30.

Date: The *Decretals* fresco was probably completed by 16 August 1511 (see Golzio, 24), and it is likely on grounds of style that the *Mass of Bolsena* portrait was executed before mid-1512 (see Oberhuber, 128). The London *Julius* belongs stylistically between these two works; for a fuller discussion of its date, see chapter three.

Drawings: A chalk study of Julius's head from life is in the Devonshire Collection at Chatsworth (36 x 25 cm.); see O. Fischel, *Raffaels Zeichnungen,* 8 vols. (Berlin, 1913–41), V, 257. A full-scale chalk and charcoal cartoon, perhaps authentic, is in the Galleria Corsini, Florence, no. 148 (109 x 82 cm.); illustrated in Klaczko, frontispiece. See also Dussler, 30.

Contemporary Characterizations of Julius

Beard: Scadinari (5 Nov. 1510), in Gozzadini, 181; Grassis (15 Dec. 1510 and 18 Feb. 1511), 213, 241; Antonio Gatico (3 Jan. 1511), in Luzio, "Federico Gonzaga," 569; Peter Martyr (March 1511), *Opus epistolarum* (Paris, 1670), Lib. XXIV, ep. 451; Giles of Viterbo (3 May 1511), in L. Pélissier, "Pour la biographie du Cardinal G. de Viterbe," *Miscellanea di studi critici edita in onore di Arturo Graf* (Bergamo, 1903), 809; Ubaldino Friano (7 May 1511), *Cronaca di Bologna,* in Gozzadini, 182; Evangelista Capodiferro (24 June 1511), in O. Tommasini, "Evangelista Maddaleni de' Capodiferro accademico . . . e storico," *Atti dell' Accademia dei Lincei,* ser. 4, I (1892), 15; Tedallini (27 June 1511 and March 1512), 321, 327; Cardinal Bibbiena (13 March 1512), in Rodocanachi, 126 n. 3; Stazio Gadio (16 March 1512) and Grossino (25 March 1512), in Luzio, "Isabella d'Este di fronte," 69–70; Capello (April 1512), in Sanuto XIV, 86; and Erasmus, 53. M. Zucker, "Raphael and the Beard of Pope Julius II," *Art Bulletin* 59 (1977), 524–33, arrived independently at an in-

terpretation of the beard which parallels our own in many respects.

Appearance: Francesco Gonzaga (30 Nov. 1503), in Luzio, "Isabella d'Este e Giulio II," 845 n. 1; Grassis (Döllinger), 492; and Andrea Bernardi (1507) in *Monumenti istorici pertinenti alle provincie della romagna,* ser. 3, *Cronache* (Bologna, 1896), II, 190.

Gout, syphilis, and drunkenness: Lucido and Cattaneo (7 Feb. 1504), Francesco Maria della Rovere (3 March 1505) and Brognolo (13 Jan. 1506), in Luzio, "Isabella d'Este e Giulio II," 845–46, 850; Scadinari in Gozzadini, 181; Grassis (Oct. 1506), 63; Trevisan (April 1510) and anonymous epitaph (Feb. 1513) in Sanuto X, 80 and XV, 564; Erasmus, 110, 112 and *passim;* Rodocanachi, 81–82 n. 4; and Guicciardini, Bk. VII, Ch. III, 645.

Personality: Marcantonio Casanova (1503), in Cian, 442; Grassis (1 June 1505), in P. Mashanaglass, "Une ambassade Portugaise à Rome sous Jules II," *Revue d'histoire diplomatique* 7 (1903), 58; Brognolo (28 Nov. 1505), "Isabella d'Este e Giulio II," 848; Albertini (1510), Bk. III, "De nova urbe"; Capello (April 1510 and 13 Jan. 1511) in Sanuto X, 73 and XI, 741; Lippomano (14 Nov. 1510 to 5 March 1511), in Sanuto XI, 642, 722, 724–25, 729–30, 745, 772–73, 776, 778, 781, 843 and XII, 12–14, 32; Archdeacon of Gabbioneta (4 and 7 Nov. 1510), Stazio Gadio (18 and 27 Nov. 1510), and Ippolito d'Este (4 Dec. 1510), in Luzio, "Isabella d'Este di fronte," 262, 266n, 270n, 273; Brognolo (22 Feb. 1510), Stazio Gadio (6 and 11 Nov. 1510, 25 Aug. 1511, and 18 Dec. 1512) and Cardinal of Mantua (20 Feb. 1513), in Luzio, "Federico Gonzaga," 510, 516n, 525–26, 546, 555; Giles of Viterbo (ca. 1513), in O'Malley, *Giles,* 6 n. 1, and K. Höfler, "Böhmische Studien," *Archiv für Kunde österreichischer Geschichts-Quellen* 12 (1854), 382–87; Tommaso In-

ghirami, in Erasmus, *Il Ciceroniano,* ed. A. Gambaro
(Brescia, 1965), 131; Giorgio Anselmi and Antonio
Flaminio in Hartt, 216 nn. 208, 209; Vasari VII, 187;
Machiavelli, 91, 254, 523, 905, 910, 1459; P. de Nolhac,
Erasme en Italie, Étude sur un épisode de la Renaissance (Paris,
1888), 14. See also Steinmann II, 29–40; Rodocanachi, 7
n. 3; and A. Fabroni, *Leonis X pontificis maximi vita* (Pisa,
1797), 280.

 Terribilità: J. Białostocki, *Stil und Überlieferung in der
Kunst des Abendlandes. Akten des 21. Internationalen Kongres-
ses für Kunstgeschichte, Bonn, 1964* (Berlin, 1967), III, 222–
25.

Renaissance Individualism

 J. Burckhardt, *The Civilization of the Renaissance in Italy*
(many eds.), especially Pt. II, "The Development of the
Individual"; much subsequent interpretation and bibliog-
raphy in W. Ferguson, *The Renaissance in Historical
Thought* (Cambridge, Mass., 1948); F. Chabod, "The
Concept of the Renaissance," *Machiavelli and the Renais-
sance* (New York, 1958), 149–247; and D. Hay, *The Italian
Renaissance in Its Historical Background,* 2nd ed. (Cam-
bridge, 1976).

Renaissance Portraiture

 General: K. Wörmann, *Die italienische Bildnismalerei der
Renaissance* (Esslingen, 1906); J. Burckhardt, "Das Porträt
in der italienischen Malerei," *Beiträge zur Kunstgeschichte
von Italien,* 2nd ed. (Berlin, 1911), 163–337; Hill, *passim;*
A. Warburg, "Bildniskunst und florentinisches Bürger-
tum," *Gesammelte Schriften* (Leipzig, 1932) I, 89–126;
J. Pope-Hennessey, *The Portrait in the Renaissance* (New
York, 1966)(important review by C. Gilbert, *Burlington
Magazine* 110 [1968], 278–85); E. Castelnuovo, "Il si-

gnificato del ritratto pittorico nella società," *Storia d'Italia* V, Pt. 2 (Turin, 1973), 1033–94; L. Sleptzoff, *Men or Supermen? The Italian Portrait in the Fifteenth Century* (Jerusalem, 1978).

State portraiture: M. Jenkins, *The State Portrait: Its Origin and Evolution* (New York, 1947); Oberhuber, *passim;* and *idem,* "Raphael and the State Portrait—II: The Portrait of Lorenzo de' Medici," *Burlington Magazine* 113 (1971), 436–43.

Papal portraits: H. Werner, *Die Ehrenstatuen der Päpste* (Leipzig, 1929); G. Ladner, *Die Papstbildnisse des Altertums und des Mittelalters,* 2 vols. (1941 and 1970); A. Haidacher, *Geschichte der Päpste in Bildern* (Heidelberg, 1965); K. Schwager, "Über Jean Fouquet in Italien und ein verlorenes Porträt Papst Eugens IV," *Argo, Festschrift für Kurt Badt* (Cologne, 1970), 206–34; Hill, *passim;* M. Meiss, "The Altered Program of the Santa Maria Maggiore Altarpiece," *Studien zur toskanischen Kunst. Festschrift für Ludwig Heydenreich zum 23. März 1963* (Munich, 1964), 169–90; Émile Gaillard, *Sano di Pietro, 1406–1481, Un Peintre Siennois au XV^e Siècle* (Chambéry, 1923), pl. 6; E. Carli, *Il Pintoricchio* (Milan, 1960), 49–51, 69–79, pls. 84–85, 122, 132, 134, 136–37, 139, 141; *Miniature del Rinascimento,* cat. 97, pl. 17; J. Pope-Hennessey, *The Portrait in the Renaissance* (New York, 1966), 11; *idem, Fra Angelico* (New York, 1952), pl. 116; P. Albright, "Pollaiuolo's Tomb of Innocent VIII" (Master's thesis, University of California, Berkeley, 1977); J. Pope-Hennessey, *Italian Renaissance Sculpture,* 317–19, fig. 115; A. Cinagli, *Le Monete de' Papi descritte in tavole sinottiche* (Fermo, 1848), nos. 66–67; M. Kahr, "Jean le Bon in Avignon," *Paragone* 197 (1966), 3–16; and P. Bonanni, *Numismata Pontificum Romanorum Quae a Tempore Martini V usque ad annum MDCXCIX,* 2 vols. (Rome, 1706).

128 References to Chapter One

Portraits of Sixtus IV: L. Ettlinger, "Pollaiuolo's Tomb
of Sixtus IV," *Journal of the Warburg and Courtauld Institutes*
16 (1953), 239–71; *idem, The Sistine Chapel,* pl. 34c;
R. Weiss, *The Medals of Pope Sixtus IV (1471–1484)*
(Rome, 1961), 28, figs. 10, 11; *Miniature del Rinascimento,*
cat. 72; P. Rotondi, *Il Palazzo Ducale di Urbino,* 2 vols.
(Urbino, 1950), 337–56; B. Biagetti, "L'Affresco di Sisto
IV e il Platina," *Melozzo da Forlì, Rassegna d'arte romagnola*
5 (1938), 227–29; A. Schiavo, "Profilo e testamento di Raf-
faele Riario," *Studi Romani* 8 (1960), 414–29; P. de Angelis
II, 378–516; M. Petrassi, "I Fasti di Sisto IV," *Capitolium*
48 (1973), 13–23; and E. Howe, *The Hospital of Santo
Spirito and Pope Sixtus IV* (New York, 1977).

Portraits of Julius: G. Zanghieri, "Il ritratto di Giulio II
di Grottaferrata presumibile copia di un Raffaello per-
duto," *Capitolium* 30 (1955), no. 7, 209–14; Klaczko, *pas-
sim;* O. Fischel, "Due ritratti di Giulio II," *Bollettino d'arte*
28 (1934), 195; *idem,* "Due ritratti non riconosciuti di
Giulio II," *L'Illustrazione Vaticana* 7, No. 11 (1936), 514;
C. de Tolnay, *Michelangelo* (Princeton, 1943), I, 219–23;
N. Huse, "Ein Bilddokument zu Michelangelos 'Julius II'
in Bologna," *Mitteilungen des kunsthistorischen Instituts in
Florenz* 12 (1966), 355–58; W. Lotz, "Sixteenth-Century
Italian Squares," *Studies in Italian Renaissance Architecture*
(Cambridge, Mass., 1977), 80–81; L. Hautecoeur, *Le pein-
ture au Musée du Louvre, II, Écoles Étrangères, École Ital-
iennes (XIII^e, XIV^e et XV^e Siècles)* (Paris, 1941), 99–100,
pl. 100; G. Carotti, "La gran pala del Foppa nell'oratorio
di Santa Maria di Castello in Savona," *Archivio storico
dell'arte,* ser. 2, I (1895), 449–65; Hill, nos. 222, 224–49,
395, 445, 659–61, 817, 843, 866–72, 873–77; Weiss, "The
Medals of Pope Julius," *passim,* Sanuto XIII, 350; Dussler,
36–37; and Hartt, 118.

Florentine portraiture in general: E. Schaeffer, *Das Floren-*

tiner Bildnis (Munich, 1904); J. Alazard, *The Florentine Portrait* (London, 1938); I. Lavin, "On the Sources and Meaning of the Renaissance Portrait Bust," *Art Quarterly* 33 (1970), 207–66; J. Schuyler, *Florentine Busts: Sculpted Portraiture in the Fifteenth Century* (New York, 1976); and J. Lanyi, "The Louvre Portrait of Five Florentines," *Burlington Magazine* 84 (1944), 87–95.

Florentine independent profile portraits: G. Pudelko, "Florentiner Porträts der Frührenaissance," *Pantheon* 15 (1935), 92–98; J. Lipman, "The Florentine Profile Portrait in the Quattrocento," *Art Bulletin* 18 (1936), 54–102; R. Hatfield, "Five Early Renaissance Portraits," *Art Bulletin* 47 (1965), 315–34; J. Mambour, "L'évolution ésthètique des profils florentins du quattrocento," *Revue Belge d'archéologie et d'histoire* 38 (1969), 43–60; and M. Ritter, "The Sources and Meanings of the Profile Portrait on the Italian Renaissance Tombs of the Fifteenth Century" (Master's thesis, University of California, Berkeley, 1976).

Independent portraits of French kings: C. Sherman, *The Portraits of Charles V of France (1338–1380)* (New York, 1969); M. Vale, "Jean Fouquet's Portrait of Charles VII," *Gazette des Beaux-Arts* 110 (1968), 243–48; and O. Pächt, "Jean Fouquet: A Study of His Style," *Journal of the Warburg and Courtauld Institutes* 4 (1940/41), 89.

Leonardo's "Mona Lisa": K. Clark, "Mona Lisa," *Burlington Magazine* 115 (1973), 144–50; and R. Huyghe, *Léonard de Vinci, La Joconde* (Fribourg, 1974).

Raphael's portraiture: M. Burkhalter, *Die Bildnisse Rafaels* (Laupen bei Bern, 1932); S. Freedberg, *Painting of the High Renaissance in Rome and Florence,* I (Cambridge, Mass., 1961), 65–66, 177–78, 333–46; Dussler, *passim*; and F. Gruyer, *Raphael, Peintre de Portraits,* 2 vols. (Paris, 1881).

Raphael's portrait of Federico Gonzaga: Golzio, 24–28.

Contemporary judgments on Raphael: Golzio, 191–93 (Giovio), 195–232 (Vasari), 294–306 (Dolce; see also M. Roskill, *Dolce's "Aretino" and Venetian Art-Theory of the Cinquecento* [New York, 1968], 205–7).

On Imitation

Ancient and Renaissance traditions: P. A. Duhamel, "The Function of Rhetoric as Effective Expression," *Journal of the History of Ideas* 10 (1949), 344–56, where the traditions behind the quotation from Quintilian (Inst. II. xiii.2) are discussed; R. Sabbadini, *Storia del Ciceronianismo* (Torino, 1885); H. Gmelin, "Das Prinzip der Imitatio in der romanischen Literatur der Renaissance," *Romanische Forschungen* 46 (1932), 85–360; M. Vitale, *La questione della lingua* (Palermo, 1960).

Pico-Bembo controversy: Le epistole "De Imitatione" di G. F. Pico della Mirandola e P. Bembo, ed. G. Santangelo (Florence, 1954) (I. Scott, trans. *Controversies over the Imitation of Cicero* [New York, 1910], 1-18).

Applications to art: E. Panofsky, *Idea: A Concept in Art Theory* [1924] (New York, 1968); R. Lee, *Ut pictura poesis: The Humanistic Theory of Painting* (New York, 1967); M. Baxandall, *Giotto and the Orators: Humanist Observers of Painting in Italy and the Discovery of Pictorial Composition, 1350–1450* (Oxford, 1971), 33ff, 65–66; E. Battisti, "Il concetto d'imitazione nel Cinquecento," *Rinascimento e Barocco* (Torino, 1960), 175–215; and M. Kemp, "From 'Mimesis' to 'Fantasia': The Quattrocento Vocabulary of Creation, Inspiration and Genius in the Visual Arts," *Viator* 8 (1977), 347–98. The texts on imitation collected in *Scritti d'arte del Cinquecento,* ed. P. Barocchi (Milan/Naples, 1973), II, 1523–607, include Raphael's letter to Castiglione, 1529–31 (also in Golzio, 30–32), and the relevant passages from Castiglione's *Book of the Courtier,* Bk. I, chaps. 26 and 53.

Physiognomics

Theory: R. Foerster, *Scriptores Physiognomici Graeci et Latini,* 2 vols. (Leipzig, 1893); P. Gauricus, *De Sculptura,* ed. A. Chastel and R. Klein (Geneva, 1969), "De Physiognomia," 128–63 (on dark eyes, 141); Leonardo da Vinci, *Treatise on Painting,* ed. and trans. A. P. McMahon (Princeton, 1956), I, 147–57 ("twice-dead" painting, 150–51).

Leonine portraits: P. Meller, "Physiognomical Theory in Renaissance Heroic Portraits," *The Renaissance and Mannerism: Acts of the 20th International Congress of the History of Art* (Princeton, 1963), II, 53–69; R. Watkins, "L. B. Alberti's Emblem, the Winged Eye, and His Name, Leo," *Mitteilungen des kunsthistorischen Instituts in Florenz* 9 (1960), 256–58; K. Forster, "Metaphors of Rule: Political Ideology and History in the Portraits of Cosimo I de' Medici," *Mitteilungen des kunsthistorischen Instituts in Florenz* 15 (1971), 65–103; and L. Ettlinger, "Hercules Florentinus," *Mitteilungen des kunsthistorischen Instituts in Florenz* 16 (1972), 119–42. The most leonine of Julian medals is Hill, no. 877.

High Renaissance Definitions of Human Potential

F. Gilbert, *Machiavelli and Guicciardini: Politics and History in Sixteenth-Century Florence* (Princeton, 1965), esp. 179ff, 326–28; O'Malley, "Preaching for the Popes," 408–40; C. Trinkaus, *In Our Image and Likeness: Humanity and Divinity in Italian Humanist Thought* (Chicago, 1970); W. J. Bouwsma, "The Two Faces of Humanism: Stoicism and Augustinianism in Renaissance Thought," *Itinerarium Italicum,* ed. H. Oberman and T. Brady (Leiden, 1975), 3–60; and P. O. Kristeller, "The Immortality of the Soul," *Renaissance Concepts of Man* (New York, 1972), 22–42.

The Lateran decree on immortality: J. D. Mansi, *Sacrorum*

Conciliorum nova et amplissima collectio 32 (Paris, 1902), col.
842–43; cf. F. Gilbert, "Cristianesimo, umanesimo e la
bolla 'Apostolici Regiminis'," *Rivista storica italiana* 79
(1967), 967–90; Thomas de Vio (Cajetan), "On the Im-
mortality of Mind," in *Renaissance Philosophy,* ed. L. Ken-
nedy (Paris, 1973), 46–54.

Late Medieval and Renaissance Papacy

General: E. R. Labande and P. Ourliac, *L'église au temps
du grande schisme et de la crise conciliaire,* 2 vols., *Histoire de
l'église* 14 (Paris, 1962–64); P. Prodi, *Lo sviluppo dell' as-
solutismo nello stato pontificio (secoli xv–xvi)* 1 (Bologna,
1968); W. Ullman, *The Growth of Papal Government in the
Middle Ages* (London, 1955); and now (with extensive bib-
liography) D. Hay, *The Church in Italy in the Fifteenth Cen-
tury* (Cambridge, 1977).

Particular aspects: E. Kantorowicz, *The King's Two
Bodies: A Study in Mediaeval Political Theology* (Princeton,
1957), 194–206; Cipriano Benet, *De sacrosancto eucharistie
sacramento* (Nuremberg, 1516), A¹; E. Lewis, "The Struc-
ture of Authority in the Church," *Medieval Political Ideas*
2 (1954), 357–429; P. Brezzi, "Lo scisma occidentale come
problema italiano," *Archivio della Deputazione Romana di
Storia Patria* 67 (1944), 391–450; H. Jedin, *History of the
Council of Trent* (St. Louis, 1957), I, 5–135; P. Partner,
"The 'Budget' of the Roman Church in the Renaissance
Period," *Italian Renaissance Studies,* ed. E. F. Jacob (Lon-
don, 1960), 256–78; M. Douglas, *Natural Symbols: Explo-
rations in Cosmology* (London, 1970), Ch. 5, "The Two
Bodies," esp. 65, and Ch. 7, "Sin and Society," esp. 104.

Social Status of Artists and Conditions of Patronage

M. Wackernagel, *Der Lebensraum des Künstlers in der
florentinischen Renaissance* (Leipzig, 1938); R. and M. Witt-
kower, *Born under Saturn: The Character and Conduct of Ar-*

tists (London, 1963); P. Burke, *Culture and Society in Renaissance Italy, 1420–1540* (New York, 1972); and M. Baxandall, *Painting and Experience in Fifteenth Century Italy* (Oxford, 1972).

Artistic "Progress": E. Gombrich, "The Renaissance Conception of Artistic Progress and Its Consequences," *Norm and Form: Studies in the Art of the Renaissance* (London, 1966), 1–10.

The quotation from Alberti is in *On Painting and on Sculpture: The Latin Texts of De Pictura and De Statua,* ed. and trans. C. Grayson (London, 1972), 94–95.

Raphael: Stylistic development: R. Wittkower, "The Young Raphael," *Allen Memorial Art Museum Bulletin* 20 (1963), 150–68; J. White, "Raphael: The Relationship between Failure and Success," *Studies in Renaissance and Baroque Art Presented to Anthony Blunt on his 60th Birthday* (London, 1967), 18–23; S. Freedberg, *Painting of the High Renaissance in Rome and Florence,* 2 vols. (Cambridge, Mass., 1961), *passim.* Courtier: Vasari IV, 383. Antiquarian: Golzio, 78–92. Prospective son-in-law of Cardinal Bibbiena: Vasari IV, 380. Palace builder: Vasari IV, 353; A. Bruschi, *Bramante architetto* (Bari, 1969), 1040–46; and C. Frommel, *Der römische Palastbau der Hochrenaissance,* 3 vols. (Tübingen, 1973), II, 80–87. Wealth: Vasari IV, 381. Mortal god, prince, and divine: Vasari IV, 316, 385, 594; and Golzio, 284–292. Raphael's self-portrait is to the extreme right in the *School of Athens.* Raphael's complaint about his loss of liberty is in a letter to Francesco Francia dated 5 Sept. 1508; see Golzio, 19–20.

Bramante: For the plan to reorient St. Peter's, see Pastor 3, 1121–22, doc. 135.

Michelangelo: Submission to Julius in Bologna, see Vasari, *La vita di Michelangelo nelle redazioni del 1550 e del 1568,* ed. P. Barocchi, 5 vols. (Milan, 1962), I, 33 and II, 387–88. For the "tragedy of the tomb," see *ibid.*; A. Con-

divi, *Life of Michelagnolo Buonarroti,* in C. Holroyd, *Michael Angelo Buonarroti* (London, 1903); and the letters of Michelangelo in E. Ramsden, *The Letters of Michelangelo,* 2 vols. (Stanford, 1963).

Quattrocento Revival of Rome

T. Magnuson, *Studies in Roman Quattrocento Architecture* (*Figura* 9) (Stockholm, 1958); Tomei, *passim;* V. Golzio and G. Zander, *L'arte in Roma nel secolo XV* (Istituto di Studi Romani, Storia di Roma 28) (Bologna, 1968); L. Gabel, "The First Revival of Rome, 1420–1484," and R. Kennedy, "The Contribution of Martin V to the Rebuilding of Rome, 1420–1431," *The Renaissance Reconsidered: A Symposium* (Smith College Studies in History 44) (Northhampton, Mass., 1964), 13–25, 27–39; E. Müntz, *Les arts à la cour des papes pendant le XV^e et XVI^e siècle,* 3 vols. (Paris, 1878–79, 1882); C. Seymour, *Sculpture in Italy, 1400 to 1500* (Harmondsworth, 1966); C. Westfall, *In This Most Perfect Paradise: Alberti, Nicholas V, and the Invention of Conscious Urban Planning in Rome, 1447–55* (University Park, Pa., 1974); G. Urban, "Die Kirchenbaukunst des Quattrocento in Rome," *Römisches Jahrbuch für Kunstgeschichte* 9/10 (1961–62), 73–289; L. Heydenreich and W. Lotz, *Architecture in Italy, 1400 to 1600* (Harmondsworth, 1974); P. Partner, *Renaissance Rome, 1500–1559* (Berkeley, 1976); and Pastor, *passim.* The speech of Nicholas V is from Pastor, *History of the Popes* 2 (St. Louis, 1902), 166.

2. ROLES OF A RENAISSANCE POPE

Beards

Julius's beard: See references to chapter one, "Contemporary Characterizations of Julius."

Princely connotations: Representations of bearded Italians before Julius include Francesco Gonzaga, Giovanni Sforza,

Albertino Papafavo da Carrara, Doge Agostino Bar-
barigo, Doge Niccolo Tron, and Cesare Borgia. See Hill,
passim; C. Gilbert, "Piero della Francesca's *Flagellation:*
The Figures in the Foreground," *Art Bulletin* 53 (1971),
43–46; and A. Heiss, *Les Médailleurs de la Renaissance* 5
(1885), 51; 7 (1887), 145–46; 8 (1891), 73. A painted panel
in the Louvre representing five famous Florentines pur-
portedly shows Uccello and Donatello as bearded, but the
identifications, and whether or not they are even portraits,
are open to question. Almost all bearded foreigners on
Italian medals before Julius are of the highest rank–
emperors, sultans, kings, or lords. Julius's encouragement
of others to grow beards is mentioned in a letter of 30
Dec. 1511 from Stazio Gadio to the Bishop of Ivrea.

Imperial connotations: Suetonius, I, LXVII, 2; and L.
Dorez, "La bibliothèque privée du pape Jules II," *Revue
des bibliothèques* 6 (1896), 97–124.

Priestly connotations: For Pope Julius I, *New Catholic En-
cyclopedia* (New York, 1967), VIII, 52; but cf. G. Ladner, *I
Ritratti dei Papi nell'antichità e nel Medioevo* (Vatican City,
1941), I, 34–35. Botticelli's fresco of the *Punishment of
Corah,* Ettlinger, *The Sistine Chapel,* 66–70. The 1513 car-
nival procession, Ademollo, 41, and Luzio, "Federico
Gonzaga," 580. For the bearded Serapis, Pirro Ligorio,
Del significato del dracone, cited in M. Fagiolo and M.
Madonna, "La casina di Pio IV in Vaticano, Pirro Ligorio
e l'architettura come geroglifico," *Storia dell'arte* 15/16
(1972), 259. The references to Valeriano's *Pro sacerdotum
barbis* are from the 1533 English edition (London) 22v–23r
and 26v.

Julius as Warrior Prince

General: Erasmus 18–19, 45, 48, 50, 110, and *passim;*
Sanuto XV, 562–66; Gilbert, no. 10, 8; and Guicciardini,
Bk. XI, Ch. VIII, 1115.

Tableaux-vivants: C. Brown, "Language as a Political Instrument in the Work of Jean Lemaire de Belges and Other Poets of the "Rhétoriquer" Tradition" (Ph.D. Diss., University of California, Berkeley, 1978), 95–165.

Woodcuts: R. Bainton, *Erasmus of Christendom* (New York, 1969), 105, and Rodocanachi, pl. 20.

Julian fortresses: Pastor III, 721, 919, and *passim;* E. Bentivoglio, "Bramante e il geoglifico di Viterbo," *Mitteilungen des kunsthistorischen Instituts in Florenz* 16 (1972), 168; Bruschi, 909–10, 938–45; and Hill, nos. 224b and g, 816 ter., 817 and 872.

Camauro and mozzetta: See references, chapter one, "Renaissance Portraiture" and subsections "Papal portraits," "Portraits of Sixtus IV," "Independent portraits of French kings," and Moroni XLVII, 27–36. Pius II might have worn the short *mozzetta* before Sixtus IV, but it is impossible to tell from his portrait on medals; see P. Bonanni, *Numismata Pontificum Romanorum,* I, 65. Examples of Italian nobles wearing long French-styled robes are Lodovico Gonzaga frescoed in the Camera degli Sposi by Mantegna in the Palazzo Ducale in Mantua (1474) and a miniature of Ercole d'Este in *De origine domus estensis* in the Biblioteca Estense of the second half of the fifteenth century. For the latter see Oberhuber, Fig. 9.

Dynasticism: E. Lee, *Sixtus IV and Men of Letters* (Rome, 1978). In Melozzo's fresco, Giovanni della Rovere, Prefect of Rome and Duke of Montefeltro, and Girolamo Riario, Count of Imola and Forlì, stand to the left; Cardinal Giuliano della Rovere (the earliest known portrait of the future Julius II) and Raffaele Riario, apostolic protonotary, later cardinal, stand to the right. Julius is in a more prominent position, directly facing Sixtus, than any of the others and is emphasized by the background elements of a column, an arch, and a silhouetting back light. For the inscriptions of dynastic significance, Tomei, 157, 176; Weiss, "The Medals of Pope Julius II," and *The Medals of*

Pope Sixtus IV; Hill, nos. 222, 229, 445, 659–61, 816 ter., 866–74; M. Cruttwell, *Antonio Pollaiuolo* (London, 1907), 192–93; Steinmann II, 56, n. 3 and 58 nn. 2, 5; and Golzio, 23, 26. For the quotation by Paris de'Grassis see Steinmann II, 176, n. 2.

Julius as Emperor

General: O'Malley, "Discovery of America," 192; *idem, Giles,* 126; Sanuto VII, 63–65; Hill, no. 875; Weiss, "The Medals of Pope Julius II," pl. 31j; *Corpus Nummorum Italicorum* 15 (Rome, 1934), pl. 17, no. 13; and B. Horrigan, "Imperial and Urban Ideology in a Renaissance Inscription," *Comitatus* 9 (1978), 73–86.

Julius Caesar: Pastor III, 663 n. 4; Sanuto VII, 64; Albertini, "Epistola"; Weisbach, 68–69; Gombrich, 119–22 (in hieroglyphics Julius was to have been represented by a profile of Julius Caesar); *Die Chronicken der Deutschen Städte* 23 (Leipzig, 1894), 103; M. Vattaso, *Antonio Flaminio e le principali poesie dell'autografo vaticano 2870* (Rome, 1900), 50–51 (also Brummer, 220, n. 22); and Hill, no. 874.

Augustus: J. Shearman, "The Vatican Stanze: Functions and Decorations," *Proceedings of the British Academy* 57 (1971), 382–83, where the *Stanza della Segnatura* is related to the Palatine Library of Augustus. When Julius established a special office concerned with the Tiber and had the Tiber dredged for the first time since antiquity (Rodocanachi, 46; Bruschi, 633–34; P. Frosini, "La liberazione dalle inondazione del Tevere," *Capitolium* 43 [1968], 227), he was following the example of Augustus (Suetonius, II, xxx, 1, and xxxvii, 1). The treaty between Julius and the rebellious Roman nobles in 1511 was glorified as the Augustan *Pax Romana;* see C. Gennaro, "La 'Pax Romana' del 1511," *Archivio della Società Romana di Storia Patria* 90 (1967), 17–60. For Julius citing the Aeneid

(I, 204ff.) on the road from Imola to Tossignano en route
to Bologna in 1506, see Pastor III, 716; Marcantonio Vida
wrote an epic (unpublished) lauding Julius's martial ac-
complishments entitled the *Juliad,* based on the *Aeneid;* see
M. Di Cesare, 3. For further Virgilian references in Julian
Rome, Brummer, 166, 229–30; O'Malley, *Giles,* 121, 128;
Vat. Lat. 1682, 28v; the inscription, *Numine afflatur*
(*Aeneid,* VI, 50), with the personification of Poetry, and
the grisaille fresco of *Augustus Preventing Virgil from Burn-
ing the Aeneid,* both in the *Stanza della Segnatura;* and the
Cumean sibyl, Virgil's prophetess of the Augustan Golden
Age through the line of Iulus (!), in the center of the Sistine
Ceiling. For Capodiferro's reference to Julius as Augustus
and Ancus, Steinmann II, 59, n. 1. (The inscription on the
fortress at Ostia also links Julius to Ancus, the 4th king of
Rome [642–17 B.C.], by stating that it was completed in
"1486, 2,115 years from the foundation of Ostia, 2,129
from Ancus Marcius founder of the city"; see Weiss, *The
Medals of Pope Sixtus IV,* 33. Paris de'Grassis, opening his
diary in 1504 after his appointment as master of cere-
monies, wrote that in order to insure that religious obser-
vances be done correctly it was necessary to record all
ceremonies just as Ancus Marcius had ordered the pon-
tifex to copy out the commentaries of Numa for public
consultation [Livy, I, xxxii, 1–2]; see Grassis [Döllinger],
364.)

Trajan: The medal inscribed *Centum Celle* (Hill, no.
872; see also nos. 244b and g) suggests a parallel between
Julius, the founder of the fortress of Civitavecchia in 1508,
and Trajan, the original founder of the Roman port.

Tiberius: Steinmann II, 786–87.

Constantine: Ettlinger, *Sistine Chapel,* 66–70, 90–93,
112–16: Grassis, 176; S. Sandström, "The Sistine Chapel
Ceiling," *Levels of Unreality: Studies in Structure and Con-
struction in Italian Mural Painting during the Renaissance*

(*Figura, Acta Universitatis Upsaliensis,* new series IV) (Uppsala 1963), 173–91 (also in C. Seymour, Jr., *Michelangelo: The Sistine Chapel Ceiling* [New York, 1972], 207–21); J. Traeger, "Raffaels Stanza d'Eliodoro und ihr Bildprogramm," *Römisches Jahrbuch für Kunstgeschichte* 13 (1971), 29–99; A. Cinagli, *Le monete de' Papi descritte in tavole sinottiche* (Fermo, 1848), 66–67; *Corpus Nummorum Italicorum* 15 (Rome, 1934), 249–56; Chevalier, 270; F. Falk, "Beiträge zur Pastors Papstgeschichte," *Zeitschrift für katholische Theologie* 22 (1898), 189; and E. Savino, "Ad Julium P. M. de donatione Constantini," *Un curioso poligrafo del quattrocento, Antonio de Ferrariis (Galateo)* (Bari, 1941), 429–42.

Julius greater than any emperor: Sanuto X, 80 and XIV, 457–58; Conti II, Bk. XV, 360; O'Malley, *Giles,* 127; *idem,* "Discovery of America," 191; and the centrally placed tondo in the Sistine Ceiling showing Alexander the Great submitting to the high priest of Jerusalem (who is dressed in papal regalia!); Sanuto (XV, 561) said that Julius "sta causa di la ruina de Italia," and Bramante, known as *ruinante,* was considered capable of destroying the whole world (Pastor III, 892).

Cortile del Belvedere: J. Ackerman, "The Belvedere as a Classical Villa," *Journal of the Warburg and Courtauld Institutes,* 14 (1951), 70–91; *idem, The Cortile del Belvedere* (Vatican, 1954); Bruschi, 291–433, 865–82; Brummer, *passim;* L. Grisebach, "Baugeschichtliche Notiz zum Statuenhof Julius' II im vatikanischen Belvedere," *Zeitschrift für Kunstgeschichte* 39 (1976), 209–20; and Hill, no. 876. The Vatican Loggie project by Bramante of ca. 1508–9 is also of imperial scale, articulation (cf. the Colosseum), and function (cf. the Septizonium of 203 A.D. which similarly screens an agglomeration of earlier buildings to present a unified facade).

Julius's tomb: Frommel, "Capella Iulia," 26–62; A.

Frazer, "A Numismatic Source for Michelangelo's First Design for the Tomb of Julius II," *Art Bulletin* 57 (1975), 53–57; Gilbert, 192; and Vasari VII, 163.

St. Peter's: Pastor III, 889; and Conti II, Bk. XV, 344.

Triumphal entries into Rome and Bologna: L. Frati, "Delle monete gettate al popolo nel solenne ingresso in Bologna di Giulio II per la cacciata di Gio. II Bentivoglio," *Atti e memorie della R. Deputazione di Storia Patria per le Provincie di Romagna,* ser. 3, I (1883), 474–87; Grassis, 84–96, 169–76; Weiss, "Medals of Pope Julius II," 163–82; Sanuto VI, 492–93 and VII, 64; Albertini, ed. Schmarsow xxii, and ed. Murray Book II, "De triumpho nonnullorum"; and Hill, no. 874.

Cleopatra and the East: Brummer, 153–84, 216–51; and E. MacDougall, "The Sleeping Nymph: Origins of a Humanist Fountain Type," *Art Bulletin* 57 (1975), 357–65. Additional links to Egypt, implying Julian connections with the earliest sources of human wisdom and dominion over the East, are the hieroglyphics intended for the Cortile del Belvedere and used in St. Peter's and the 1513 carnival procession. See Gombrich, 119–25; R. Wittkower, "Hieroglyphics in the Early Renaissance," *Developments in the Early Renaissance,* ed. Bernard S. Levy (Albany, 1972); Frommel, "Die Peterskirche," docs. 197, 209, pp. 111–12; Ademollo, 40; and Luzio, "Federico Gonzaga," 580. Julius's connections and dominion over Greece and the Holy Land are implied by Battista Casali (see O'Malley, "The Vatican Library," 271–87) and the following visual representations: *Parnassus, Alexander the Great Placing the Iliad of Homer in Safekeeping, School of Athens, Blinding of Zaleucus,* and *Justinian Receiving the Pandects* in the *Stanza della Segnatura; Expulsion of Heliodorus* in the *Stanza d'Eliodoro; Submission of Alexander the Great to the High Priest of Jerusalem* and *Judas Maccabaeus Defeats Nicanor* on the Sistine Ceiling; and the illumination in a Vatican

manuscript by Michele Nagoni (see Weisbach, 68–69). In addition, the central plan of the new St. Peter's was derived ultimately from the martyria of the Holy Land.

Cloth

Imperial mappa: Pauly-Wissowa, XIV, Pt. 2, 1414–15; C. Daremberg, *Dictionnaire des antiquités grecques et romaines* (Paris, 1877), 1593–95; R. Delbrueck, *Die Consulardiptychen u. verwandte Denkmaler* (Studien zur Spätantikenkunstgeschichte 2) (Berlin, 1929). For the Virgin holding the *mappa* in early Christian art, see O. Montenovesi, *Le Madonne antiche delle catacombe e delle chiese romane* (Rome, 1904), 37, 39, 53. For fifteenth-century knowledge that Constantine was consul four times and that the office was assumed on the first of January, see Valla, 137–39.

Marriage context: Legg, 191–95; E. Mellencamp, "A Note on the Costume of Titian's Flora," *Art Bulletin* 51 (1969), 174–77, especially figs. 1, 5–8, and 177, n. 17; E. Verheyen, "Der Sinngehalt von Giorgiones 'Laura'," *Pantheon* 26 (1968), 220–27; and E. Panofsky, *Problems in Titian: Mostly Iconographic* (New York, 1969), 137–38 (but cf. J. Held, "Flora: Goddess and Courtesan," *De Artibus Opuscula XL: Essays in Honor of Erwin Panofsky,* ed. M. Meiss [New York, 1961], 216). Although dating from the 1560s, the report that Pietro Carnesecchi went to his execution "fashionably dressed in a white shirt, with a new pair of gloves and a white handkerchief in his hand as though to a wedding," would certainly seem to put the *mappa* into a marriage context (see D. Cantimori, "Italy and the Papacy," *New Cambridge Modern History* [1967], II, 267). For the Villa Lemmi frescos, see H. Ettlinger, "The Portraits in Botticelli's Villa Lemmi Frescoes," *Mitteilungen des kunsthistorischen Instituts in Florenz* 20 (1976), 404–6.

For purifying the hands: R. Hatfield, *Botticelli's Uffizi "Adoration": A Study in Pictorial Content* (Princeton, 1976), 35–41.

Maniple: Norris, 92–94; King, 214–17; J. Legg, *Church Ornaments and Their Civil Antecedents* (Cambridge, 1917), 63–66; and F. Bock, *Geschichte der liturgischen Gewänder des Mittelalters* (Bonn, 1866), II, 62–83. Other examples in the Renaissance where persons hold a cloth seemingly in either a quasi-liturgical or imperial context are Ghirlandaio, *Portrait of Lucrezia Tornabuoni* (see J. Lauts, *Domenico Ghirlandaio* [Vienna, 1943], fig. 103); Michelangelo, *Lorenzo de' Medici* in the Medici Chapel; Scipione Pulzone, *Portrait of Cardinal Alessandro Farnese* in the Galleria Nazionale, Rome (see F. Zeri, *Pittura e Controriforma, L'arte senza tempo di Scipione da Gaeta* [Torino, 1957], colorplate II); and two portraits of Eleanora da Toledo in Berlin and the Palazzo Vecchio in Florence (see Venturi *Storia dell'arte italiana* [Milan, 1901–39], IX, Pt. 6, 21, fig. 3, and 341, fig. 193).

Acorns and Oak

Food of Arcadia: for example, Plutarch, *Moralia* 4, "Quaestiones Romanae," 92; further, Pauly-Wissowa, V, 2027, "Eiche."

Capitoline oak: Livy I, X, 5; and Ovid, *Metamorphoses* XV, 560–64.

Aeneas's oak: Virgil, *Aeneid* VIII, 615–16.

Oak as fortitude: E. Wind, "Platonic Justice: Designed by Raphael," *Journal of the Warburg and Courtauld Institutes* 1 (1937/38), 70.

Tree-of-life and cross: P. Berchorius, *Ovidius Moralizatus* (Paris, 1509), fol. 92, and Hartt, 133.

Golden age and renewal: O'Malley, "Fulfillment"; Hartt, 133, n. 128; Di Cesare; and A. Capelli, *Lettere di L. Ariosto* (Milan, 1887), 345. Pomponius Gauricus, Giovanni Au-

relio Augurello, Lancino Corte, and Antonio Mancinelli all wrote poems celebrating the return of the Golden Age under Julius, on the occasion of his election to the papacy; see Cian, 442. For the long tradition of trees and reform see G. Ladner, "Vegetation Symbolism and the Concept of Renaissance," *De Artibus Opuscula XL: Essays in Honor of Erwin Panofsky,* ed. M. Meiss (New York, 1961), 303–22.

Oak and good shepherd: Hill, 661.

Entry into Orvieto: Grassis, 34, 89.

Float in front of S. Maria in Traspontina: Grassis, 175, and Sanuto VII, 64. For the *meta* of Romulus in front of the church, see R. Valentini e Giuseppe Zucchetti, *Codice Topografico della Città di Roma* (Rome, 1953), IV, 497.

Holy League float of 1513 apotheosis: Luzio, "Federico Gonzaga," 580–81, and Ademollo, 41.

Hostile use: Sanuto VI, 463, and Pastor III, 784.

Gems and Rings

Julian: Moroni II, 66; F. Cancellieri, *Notizie sopra l'origine e l'uso dell'anello pescatorio e degli altri anelli ecclesiastici e specialmente del cardinalizio* (Rome, 1823), 15; M. Tafuri, *Via Giulia, una utopia urbanistica del '500* (Rome, 1973), 431–32; Luzio, "Federico Gonzaga," 525, 542; *idem,* "Isabella d'Este di fronte," 327; Grassis (Döllinger), 429, 432; Grassis, *passim;* Rodocanachi, 82–83; Sanuto X, 283; Bernardi, 190; L. Baldiserri, "Giulio II in Romagna (1 settembre 1510–26 giugno 1511)," *Rivista storico-critica delle scienze teologiche* III (1907), 570; Pastor III, 716, 718; and Raphael's *Decretals* fresco.

Function and symbolism of rings: F. Bock, *Geschichte der liturgischen Gewänder des Mittelalters* (Bonn, 1866), II, 205–12; A. Fourlas, *Der Ring in der Antike und im Christentum* (Munster, 1971); Moroni II, 58–71; G. Kunz, *Rings for the Finger* (Philadelphia, 1917), 249–87; J. Legg, 181–218;

P. Castelli et al., "Le virtù delle gemme, Il loro significato simbolico e astrologico nella cultura umanistica e nelle credenze popolari del Quattrocento. Il recupero delle gemme antiche," *L'oreficeria nella Firenze del Quattrocento* (Florence, 1977); F. Murphy and J. Nabuco, "Rings," *New Catholic Encyclopedia* (Washington, 1967), XII, 505–7; J. Jungmann, *The Mass of the Roman Rite,* rev. ed. (New York, 1959), 480–81; H. Leclerq, "Anneaux," *Dictionnaire d'archéologie chrétienne* (Paris, 1904), I, 2174–223; King, 146–47, 368; and Norris, 183–86. In a colloquium (January 1979) for the Department of History at Berkeley on marriage rites in Renaissance Italy, Dr. Christiane Klapisch-Zuber illustrated "the triumph of the ring" around 1500.

Julius as Priest

General: Since Julian roles overlapped, many of the references above for "Julius as Warrior Prince" and "Julius as Emperor" are also relevant here.

Julius I: Bibliotheca Sanctorum 6 (Rome, 1965), cols. 1235–36; Sanuto X, 159; and papal bull of 26 May 1510 (Santa Maria in Trastevere, Archivio del vicariato, Liber I, Instrumentorum, fol. 127r. ff.), for which references, our thanks to Prof. Dale Kinney.

Church liberty: Machiavelli I, 46; Weiss, 164–66; and Conti II, Lib. XV, 296. Julius first articulated his policy of "church liberty" by the inscription on a medal of the 1480s by Sperandio (Hill, no. 395) made in connection with his appointment as bishop of Bologna: *Iulianus Ruvere S. Petri ad Vincula Cardinalis Libertatis Ecclesiastice Tutor.* On the reverse is an allegory of the Church as the agent of salvation inscribed "Celestial Life." The ship evidently symbolized the Church; the pelican of piety on the bow, as well as the mast and yard, Christ's redemptive sacrifice that gave the Church its authority; and the water,

the rite of baptism by which the fruits of Christ's sacrifice were channeled to the faithful. Within the *navicella* the dog (?) represented faith, and Minerva (?) holding a spear, the strength and divine wisdom of the Church.

Crusades: O'Malley, "The Vatican Library," 277; *idem,* "Fulfillment," 324–28, 334–35, 338; *idem, Giles,* 14–15; *idem,* "The Discovery of America," 190; Frommel, "Die Peterskirche," doc. 216; Weisbach, 68–69; Grassis (Döllinger), 390; Minnich, "Concepts of Reform," 166; Luzio, *Le letture,* 4–5; Steinmann, "Chiaroscuri in den Stanzen Raffaels," *Zeitschrift für Bildende Kunst* 10 (1898/99), 169–78; Pastor III, 662, 711, 728–29, 786–87, 821.

Justice, peace, and reform: Bernardi, 395; O'Malley, *Giles,* 154 and *passim; idem,* "Discovery of America," *passim;* Minnich, "Concepts of Reform," *passim;* Sanuto VII, 64; Pastor III, 848–49; Grassis (Döllinger), 432; Steinmann II, 786–87; and Hill, nos. 222, 877.

Palace of Justice: L. Salerno, L. Spezzaferro, and M. Tafuri, *Via Giulia, Una utopia urbanistica del '500* (Rome, 1973), 15–152, 314–22; C. Frommel, "Il Palazzo dei Tribunali in Via Giulia," *Studi Bramanteschi, Atti del Congresso internazionale* (Milan, 1970), 523–34; S. von Moos, *Turm und Bollwerk, Beiträge zu einer politischen Ikonographie der italienischen Renaissancearchitektur* (Zurich, 1974), 83–88; and Hill, nos. 225, 227.

Julius as Solomon and David: Pastor III, 900–901; Frommel, "Die Peterskirche," *passim*; and *idem,* " 'Capella Iulia'," *passim.*

Historical Continuity, Millenarianism, and Rome in Julian Spirituality

Especially useful in a vast literature, R. Brentano, *Rome before Avignon* (New York, 1974); N. Cohn, *The Pursuit of the Millennium* (Fairlawn, N. J., 1957); J. Comblin, "La liturgie de la nouvelle Jerusalem," *Ephemerides theologicae*

lovanienses 29 (1953), 5–40; C. Davis, *Dante and the Idea of Rome* (Oxford, 1957); R. Folz, *The Concept of Empire in Western Europe from the 5th to the 14th Century* (London, 1969); W. Goez, *Translatio Imperii: Ein Beitrag zur Geschichte des Geschichtsdenkens und der politischen Theorien im Mittelalter und in der frühen Neuzeit* (Tübingen, 1958); A. Graf, *Roma nella memoria e nelle immaginazioni del medio evo* (Turin, 1915); R. Konrad, "Das himmlische und das irdische Jerusalem im mittelalterlichen Denken: Mystische Vorstellung und geschichtliche Wirkung," *Speculum Historiale,* ed. C. Bauer, L. Boehm, and M. Müller (Munich, 1965), 423–41; Minnich, "Concepts of Reform," 163–251; O'Malley, "Fulfillment," 265–338; *idem,* "Giles of Viterbo: A Reformer's Thought"; *idem,* "Giles of Viterbo: A Sixteenth Century Text," 445–50; *idem, Giles, passim; idem,* "Historical Thought," 531–48; *idem,* "Man's Dignity," 389–416; *idem,* "Erasmus and Luther," 47–65; *idem,* "The Discovery of America," 185–200; *idem,* "The Vatican Library," 271–87; M. Reeves, *The Influence of Prophecy in the Later Middle Ages* (Oxford, 1969); P. Schramm, *Kaiser, Rom und Renovatio* (Leipzig, 1929); M. Seidlmayer, "Rom und Romgedanke im Mittelalter," *Speculum* 7 (1956), 395–412; A. Walz, "Von Cajetans Gedanken über Kirche und Papst," *Volk Gottes,* ed. J. Hofer (Freiburg, 1967), 336–60; D. Weinstein, *Savonarola and Florence* (Princeton, 1970); and M. Wilks, *The Problem of Sovereignty in the Later Middle Ages: The Papal Monarchy with Augustinus Triumphus and the Publicists* (Cambridge, 1963). For further bibliography, see L. Partridge, "Divinity and Dynasty at Caprarola: Perfect History in the Room of Farnese Deeds," *Art Bulletin* 60 (1978), nn. 172–82.

Julius's "good death": Luzio, "Federico Gonzaga," 55; *idem, Le Letture,* 6; O. Raynaldi, *Annales ecclesiastici,* n. 9; *Memorie perugine di Teseo Alfani dal 1502 al 1527,* ed. F. Bonaini, *Archivio storico italiano,* ser. 1, XVI.2 (1851), 263

and n. 1; Pastor III, 844–45; Grassis (Döllinger), 432; Bernardi, 394–97; Tedallini, 338–39; and O. Tommasini, *La vita e gli scritti di Niccolò Machiavelli* (Rome, 1911), II, 1113.

Integrity and piety: Conti 2, Bk. XV, 296; Steinmann I, 580, n. 3; Sanuto XIV, 458; and Pastor III, 847–48.

Themes in the Stanze and Sistine Ceiling: it must suffice to refer for an enormous bibliography to the suggestive discussions in works by Hartt, Sandström, Seymour, Shearman, Steinmann, and Traeger cited above, under "Julius as Emperor," "Julius as Priest." Cf. also H. Pfeiffer, *Zur Ikonographie von Raffaels Disputa, Egidio da Viterbo und die christlich-platonische Konzeption der Stanza della Segnatura* (Rome, 1975).

Julius and Erasmus

Erasmus, introduction and 88–90; and J. McConica, "Erasmus and the 'Julius': A Humanist Reflects on the Church," *The Pursuit of Holiness in Late Medieval and Renaissance Religion,* ed. C. Trinkaus and H. Oberman (Leiden, 1974), 444–71.

3. THE SETTING AND FUNCTIONS OF A RENAISSANCE PORTRAIT

Santa Maria del Popolo

Julius's appearances: Grassis, 21–22, 169–72, 291–93; Grassis (Döllinger), 385, 412; Sanuto XIII, 76; Pastor III, 794; and C. O'Reilly, "'Maximus Caesar et Pontifex Maximus'," *Augustiniana* 22 (1972), 80–117 (the direct quotations from the 1512 address of Giles are on pp. 102–3 and 110–12).

History: T. Ashby and S. Pierce, "The Piazza del Popolo, Rome: Its History and Development," *Town Planning Review* 11 (1924), 75–96; E. Lavagnino, *Santa Maria*

del Popolo (Le Chiese di Roma Illustrate 20) (Rome, 1925);
Huelsen, *passim;* P. Rotondi, *La Chiesa di Santa Maria del
Popolo e suoi monumenti* (Rome, 1930); R. Valentini and
G. Zucchetti, *Codice Topografico della Città di Roma* 4
(Rome, 1953); and Buchowiecki III, 102–51.

Architecture: Tomei, 117–22; G. Urban, "Die Kirchen-
baukunst des Quattrocento in Rom," *Römisches Jahrbuch
für Kunstgeschichte* 9/10 (1961/62), 73–289; Angelis II,
407–516; Bruschi, 435–62, 911–21; L. Heydenreich and
W. Lotz, *Architecture in Italy, 1400–1600* (Baltimore,
1974); S. Valtieri, "Santa Maria del Popolo in Roma,"
L'Architettura 236 (1975), 44–55; S. Bentivoglio, "Il Coro
di S. Maria del Popolo e il Coro detta 'Del Rossellino' di
S. Pietro," *Mitteilungen des kunsthistorischen Instituts in
Florenz* 20 (1976), 197–204; Bentivoglio and Valtieri, *pas-
sim;* Frommel, "'Cappella Iulia'," 49–50, n. 97.

For a Renaissance reconstruction of the "Temple of
Peace," which includes vaults, apse, and serlian windows
similar to those of the Popolo, see Lotz, 53, fig. 16. For an
earlier example of a citation of the temple, another recon-
struction drawing, and its New Jerusalem connotations in
a fifteenth-century fresco cycle, see E. Borsook and J. Of-
ferhaus, "Storia e leggende nella cappella Sassetti in Santa
Trinità," *Scritti di Storia dell'Arte in Onore di Ugo Procacci,*
ed. M. and P. dal Poggetto (Milan, 1977), 289–310, esp.
fig. 288.

The empty wreath in the shell of the apse probably con-
tained the Julian arms, as suggested by the analogy with
the tombs. At the top of the tombs the papal arms are
placed in front of a shell at the feet of God the Father. The
suggestion by Bentivoglio and Valtieri, 26 and 35–36, that
the wreath contained the arms of Alexander VI is not
convincing.

*Sculpture: Rome. S. Maria del Popolo. Archive 2: 15th and
16th Century Sculpture in Italy,* ed. I. C. Hill, Courtauld

Institute Illustration Archives (London, 1976); E. Panofsky, *Tomb Sculpture* (New York, 1964), 82; Pope-Hennessey, *Italian Renaissance Sculpture,* 66, 287, 322–23; idem, *Italian High Renaissance and Baroque Sculpture,* I, 41, 54–66 and III, 45–51; and Bentivoglio and Valtieri, 69, 164–65 (Ascanio Sforza).

Icon and high altar: J. Wilpert, *Die römischen Mosaiken und Malereien der kirchlichen Bauten vom IV bis XIII Jahrhundert* (Freiburg, 1916), IV, 299, no. 2; and Bentivoglio and Valtieri, 28, n. 19, 30, n. 27, 175–77 , 198–99.

Sixtus IV, Andrea Bregno, and Julius II were not alone in responding to the Popolo Madonna as a miracle working icon. Pius II paraded the image as part of his campaign against the Turks in 1463. Alexander VI gave thanks at the Popolo for narrowly escaping death when a chimney fell in the Vatican during a storm (Bentivoglio and Valtieri, 28 nn. 18, 54).

Painting: A. Schmarsow, *Bernardino Pinturicchio in Rom* (Stuttgart, 1882); J. Schulz, "Pinturicchio and the Revival of Antiquity," *Journal of the Warburg and Courtauld Institutes* 25 (1962), 35–55; E. Carli, *Il Pintoricchio* (Milan, 1960), 83–85.

The inscriptions of the sibyls in the vault are *Germen virginis erit salus gentium* (Persian); *In ultima etate humanabitur deus* (Erithean); *Dei filius incarne veniet ut iudicet orbem* (Crimean); *Invisibile verbum paleabitur* (Delphic).

Stained glass: G. Mancini, *Guglielmo di Marcillat* (Florence, 1909).

Relics: Dizionario delle reliquie e dei santi della chiesa di Roma (Florence, 1871), 170, and Huelsen, 150–51.

Virgin Mary

Sixtus IV: Pastor 2, *passim;* Chevalier, *passim;* Ettlinger, *Sistine Chapel,* 14–15; Angelis II, 407–516; Lotz, 68; and H. Ost, "Santa Margherita in Montefiascone: A Cen-

tralized Building Plan of the Roman Quattrocento," *Art Bulletin* 52 (1970), 373–89.

Julius II: See references, chapter one, "Renaissance Portraiture," subsection "Portraits of Julius"; E. Motta, "L'Università dei pittori milanesi nel 1481 con altri documenti d'arte del Quattrocento," *Archivo storico lombardo,* ser. 3, 22 (1895), 424; and N. Nilles, *De rationibus festorum sacratissimi Cordis Jesu et purissimi Cordis Mariae* (Oeniponte, 1885), II, 481–82.

Loreto: Chevalier, 233–34, 241–50, 251–71, and *passim;* Bruschi, 252–667, 960–69; Hill, nos. 868, 869; Pope-Hennessey, *Italian High Renaissance and Baroque Sculpture* III, 48–50; Pastor III, 760–61, 769 n. 2 and 785; Grassis, 190; and Luzio, "Federico Gonzaga," 526.

S. Maria di Loreto, Rome: S. Benedetti, *S. Maria di Loreto (Le chiese di Roma illustrate,* 100) (Rome, 1968).,

Raphael's "Madonna of the Veil": S. Vögelin, *Die Madonna von Loretto* (Zurich, 1870); F. Gruyer, *La Peinture au Château de Chantilly* (Paris, 1896), 91–93; L. Pfau, *Die Madonna von Loretto* (Zurich, 1922); F. Filippini, "Le vicende della Madonna di Loreto di Raffaello," *L'Illustrazione Vaticana* 5 (1934), 107–9; A. Scharf, "Raphael and the Getty Madonna," *Apollo* 79 (1964), 114–21; Dussler, 27–28; and B. Fredericksen, "New Information on Raphael's *Madonna di Loreto,*" *The J. Paul Getty Museum Journal* 3 (1976), 5–45.

Ex votos: J. von Schlosser, "Geschichte der Porträtsbildnerei in Wachs," *Jahrbuch der kunsthistorischen Sammlungen des allerhöchsten Kaiserhauses* 29 (1911), 171–258; A. Warburg, "Bildniskunst und florentinisches Bürgertum," *Gesammelte Schriften* 1 (Leipzig, 1932), 89–126; Vasari III, 274; Arcangelo Maria Giani, *Annalium Sacri Ordiniis Fratrum Servorum B. Mariae Virginis* 2 (Florence, 1622), 46 (*ex voto* of Sixtus IV in SS. Annunziata); Sanuto XIII, 350 (S. Marcello portrait of Julius; for the burning of S. Mar-

cello see Buchowiecki II, 344); and R. Trexler, "Floren-
tine Religious Experience: The Sacred Image," *Studies in
the Renaissance* 19 (1972), 7–42.

EPILOGUE: THE JULIAN IMAGE AND
HIGH RENAISSANCE CULTURE IN ROME

Perspectives on High Renaissance Culture

Vasari IV, 7–15; W. Ferguson, *The Renaissance in His-
torical Thought* (Cambridge, Mass., 1948), 59–67; *Storia
d'Italia* (Torino, 1974), I, 329–85; R. Lopez, "Hard Times
and Investment in Culture," *The Renaissance: A Sym-
posium* (New York, 1952); W. Bouwsma, "Changing As-
sumptions in Later Renaissance Culture," *Viator* 7 (1976),
421–40; M. Foucault, *The Order of Things* (New York,
1973), 32; and N. Frye, *Anatomy of Criticism* (Princeton,
1957), 33–34, 119–120.

Credits for Photographs

Alinari/Anderson: 5, 6, 8, 10, 12, 15, 16, 17, 18, 19, 21, 22, 28, 29, 33, 34, 37, and 40.

Archives Photographiques: 3, 9, 11, 14, 24, 38, and 39.

Archivio Fotografico delle Gallerie e Musei Vaticani: 4 and 25.

R. Bainton, *Erasmus of Christendom* (New York, 1969), 105: 23.

Courtauld Institute: 20.

R. Delbrueck, *Die Consulardiptychen* (Berlin, 1929), Pl. 32: 26.

G. Fontana, *Raccolta delle migliori chiese di Roma e suburbane* (Rome, 1855), Pl. LVIII: 35 and 36.

Fototeca Unione, Rome: 7.

Gabinetto Fotografico Nazionale, Rome: 31 and 32.

G. Hill, *A Corpus of Italian Medals of the Renaissance before Cellini,* 2 vols. (London, 1930), No. 874: 27.

J. Klaczko, *Rome in the Renaissance: Pontificate of Julius II* (New York, 1903): 13.

The National Gallery, London: 1 and 2 (reproduced by courtesy of the Trustees).

J. Wilpert, *Die römischen Mosaiken und Malereien,* IV (Freiburg, 1916), Pl. 299, No. 2: 30.

Index

Designer:	Eric Jungerman
Compositor:	Interactive Composition Corporation
Printer:	Thomson–Shore, Inc.
Binder:	Thomson–Shore, Inc.
Text:	VIP Bembo
Cloth:	Holliston Roxite B 53538
Paper:	60 lb. P&S Laid Offset

Plates

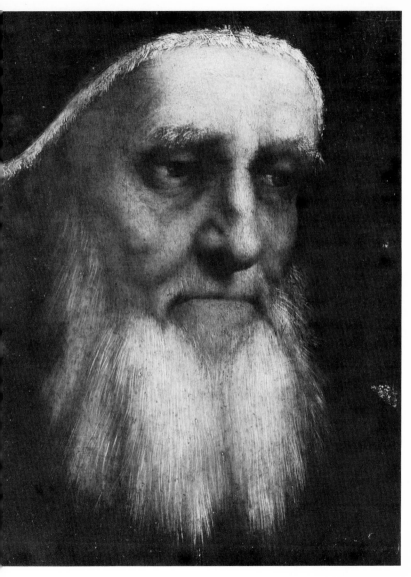

1. Raphael, *Portrait of Pope Julius II* (detail), 1511–12. London, National Gallery.

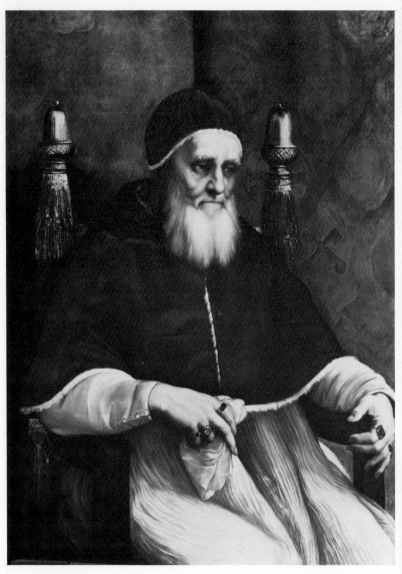

2. Raphael, *Portrait of Pope Julius II,* 1511–12. London, National
Gallery.

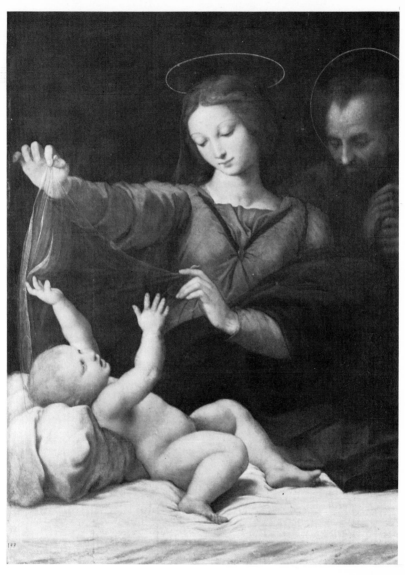

3. Raphael (?), *Madonna of the Veil,* c. 1508–9. Chantilly, Musée
Condé.

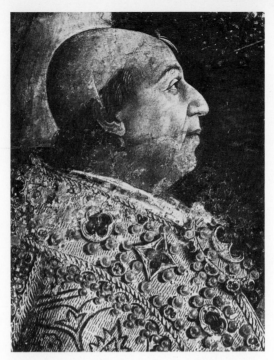

4. Pinturicchio, *Pope Alexander VI* (detail from the *Resurrection*), c. 1492–94. Fresco. Vatican, Borgia Apartments.

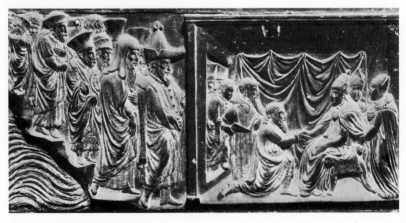

5. Filarete, *Pope Eugenius IV Receives Emperor John Paleologus,* c. 1440–45. Bronze Doors (detail). Vatican, St. Peter's.

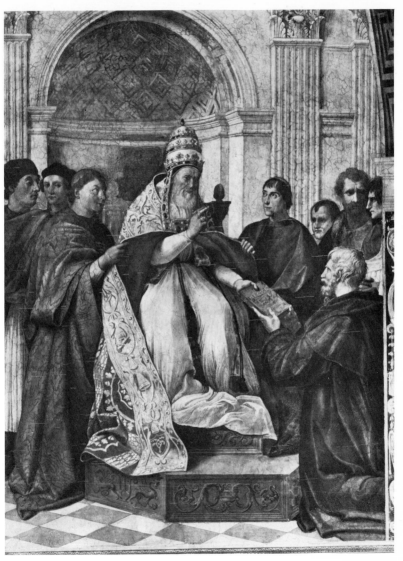

6. Raphael, *Pope Gregory IX (as Pope Julius II) Receives the Decretals in 1234*, 1511. Fresco. Vatican, Stanza della Segnatura.

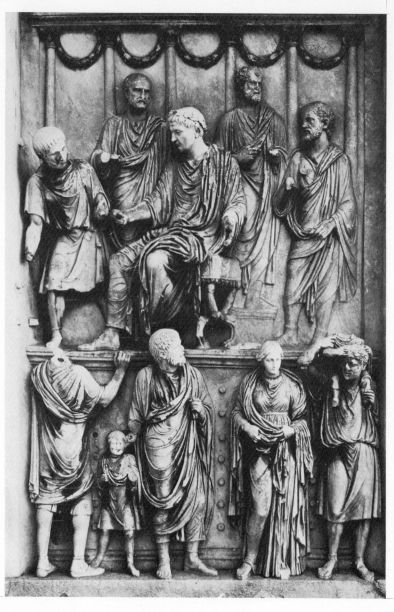

7. Aurelian Relief, *Liberalitas Augusti,* 161–80 A.D. Rome, Arch of
Constantine, 312–15 A.D.

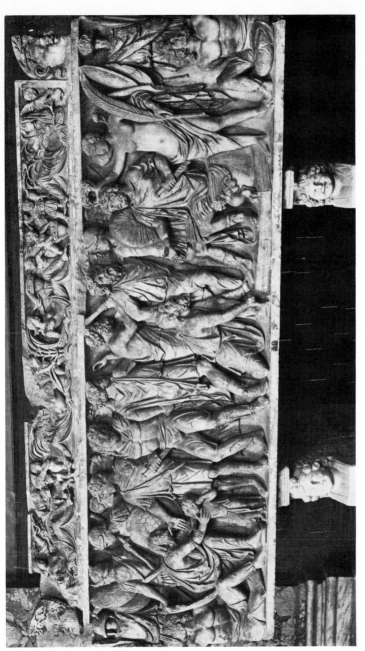

8. Roman Sarcophagus, *Roman Emperor Crowned by Victory Receives Captives*. Vatican Museum.

9. Justus of Ghent, *Pope Sixtus IV*, c. 1474. From the *studiolo* in the Palazzo Ducale, Urbino. Louvre, Paris.

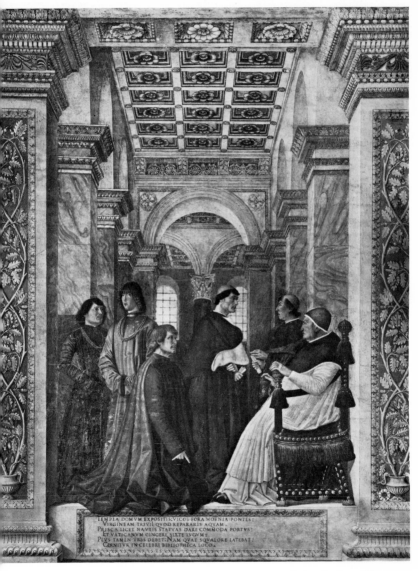

10. Melozzo da Forlì, *Pope Sixtus IV Appoints Platina Prefect of the Vatican Library*, 1476–77. Fresco. From the Vatican Library. Vatican, Pinacoteca.

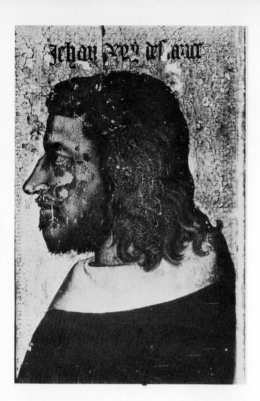

11. Anonymous, *Portrait of John the Good,* c. 1360–64. Paris, Louvre.

12. Fouquet, *Portrait of Charles VII,* mid-fifteenth century. Paris, Louvre.

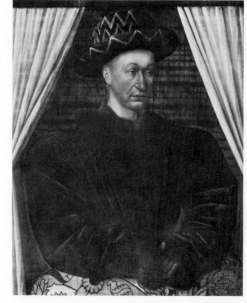

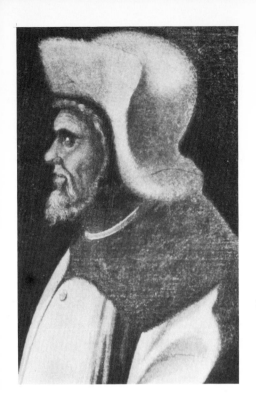

13. Anonymous, *Portrait of Julius II in 1510–11*. Mid-sixteenth-century copy. Tarquinia, Museo Nazionale.

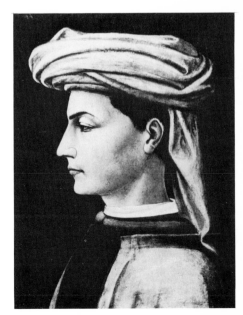

14. Uccello (?), *Portrait of a Man,* 1430s. Chambéry, Musée des Beaux-Arts.

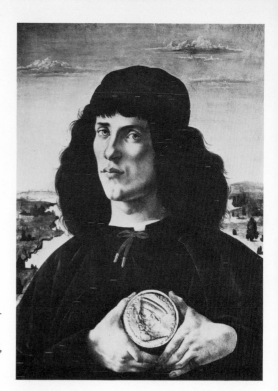

15. Botticelli, *Portrait of a Man with a Medal of Cosimo de' Medici*, 1470s. Florence, Uffizi.

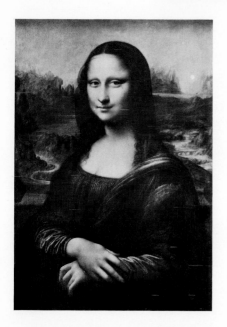

16. Leonardo, *Portrait of Mona Lisa*, 1504–10. Paris, Louvre.

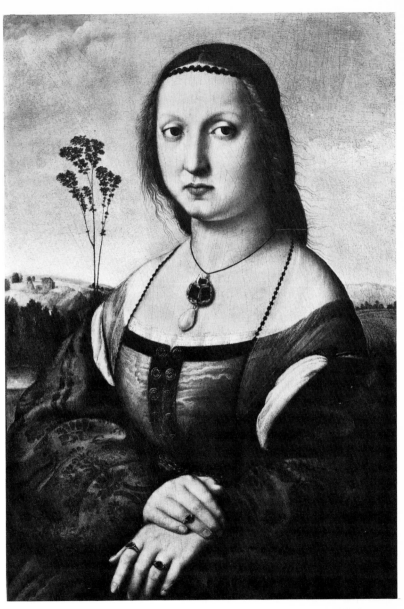

17. Raphael, *Portrait of Maddalena Doni,* c. 1506. Florence, Pitti.

18. Raphael, *Portrait of Agnolo Doni,* c. 1506. Florence, Pitti.

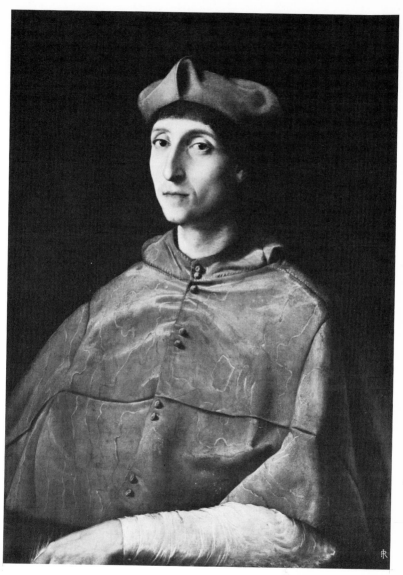

19. Raphael, *Portrait of a Cardinal*, c. 1510. Madrid, Prado.

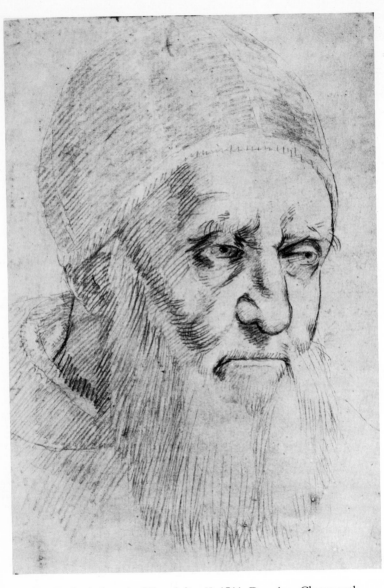

20. Raphael, *Portrait of Pope Julius II*, 1511. Drawing. Chatsworth, Duke of Devonshire Collection.

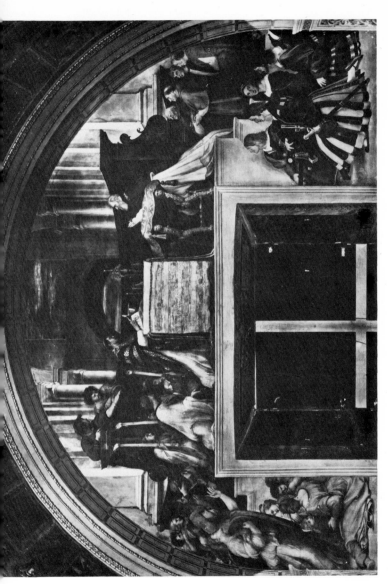

21. Raphael, *Mass of Bolsena*, c. 1512. Fresco. Vatican, Stanza d'Eliodoro.

22. Raphael, *Expulsion of Heliodorus*, c. 1512. Fresco. Vatican, Stanza d'Eliodoro.

23. Anonymous, *Pope Julius II Excluded from Heaven*. Woodcut. Title page of the 1522–23 German edition of Erasmus, *Julius Exclusus*.

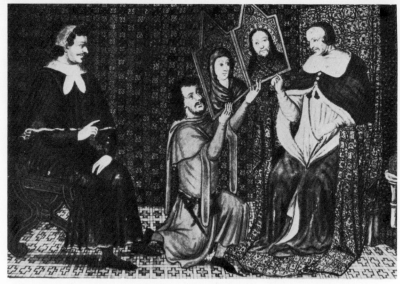

24. After Matteo Giovanetti of Viterbo (?), *Portrait of Pope Clement VI Receiving a Diptych in the Presence of John the Good*, c. 1342. From the sacristy of St. Chapelle, Paris. Paris, Bibliothèque Nationale, Estampes, Oa 11, fol. 85.

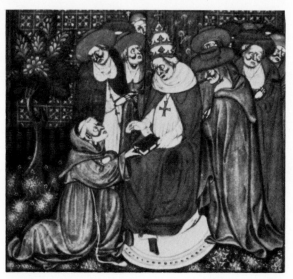

25. Anonymous, *Antonio da Rho Presents His Three Dialogues on the Errors of Lactantius to Pope Eugenius IV*, c. 1431–47. Vatican, Lat. Vat. 227.

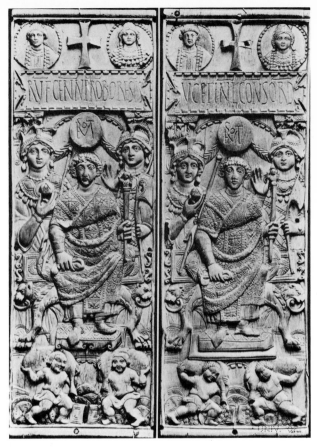

26. Consular Diptych, *Consul Orestes,* 530 A.D. Ivory.
London, Victoria and Albert Museum.

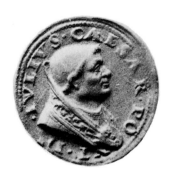 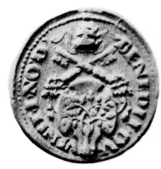

27. Anonymous, *Portrait of Pope Julius II* inscribed IVLIVS
CAESAR PONT II, obverse; *Rovere and Papal Arms*
inscribed BENEDI[CTVS] QV[I] VENIT I[N] NO[MINE]
D[OMINI], reverse; 1507. Bronze medal.

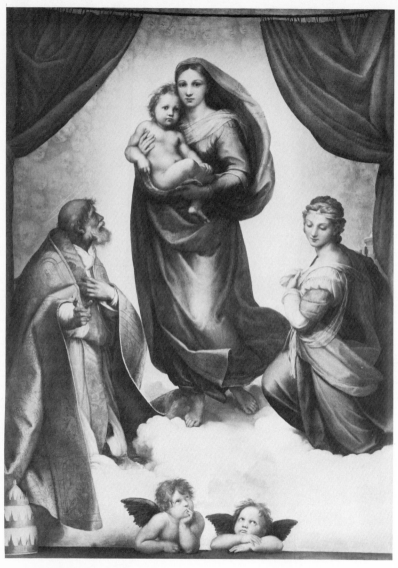

28. Raphael, *Sistine Madonna,* c. 1512–13. Dresden, Gemäldegallerie.

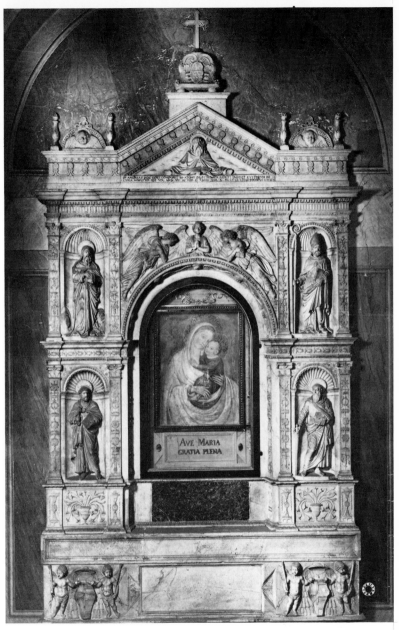

29. Andrea Bregno, *Altarpiece,* 1473. Marble. From the high altar of Santa Maria del Popolo. Rome, Santa Maria del Popolo, Sacristy.

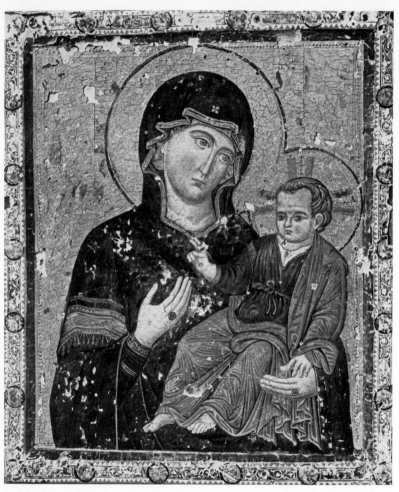

30. Anonymous, *Virgin and Child,* c. 1300. Rome, Santa Maria del Popolo, high altar.

31. Anonymous, *Before the Birth of Pope Sixtus IV, an Icon of the Virgin and Child and SS. Francis and Anthony Appear to His Mother Luchina*, 1478–84. Fresco. Rome, Hospital of Santo Spirito.

32. Anonymous, *Pope Sixtus IV Founds Santa Maria del Popolo*, 1478–84. Fresco. Rome, Hospital of Santo Spirito.

33. Andrea Sansovino, *Tomb of Ascanio Sforza,* 1505. Marble. Rome, Santa Maria del Popolo, Choir.

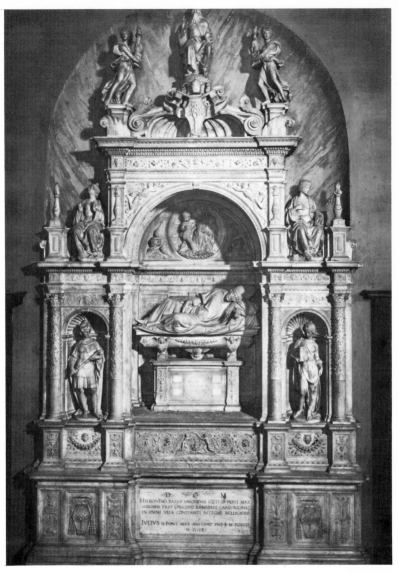

34. Sansovino, *Tomb of Girolamo Basso della Rovere*, 1507. Marble.
Rome, Santa Maria del Popolo, Choir.

35. After Marcillat, *Life of the Virgin,* c. 1509–10. Stained glass.
Rome, Santa Maria del Popolo.

36. After Marcillat, *Life of Christ,* c. 1509–10. Stained glass.
Rome, Santa Maria del Popolo.

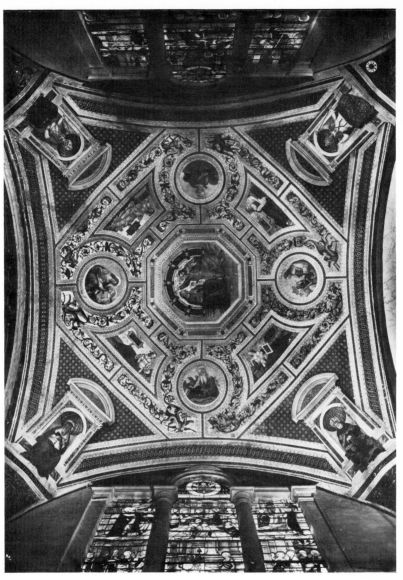

37. Pinturicchio, *Vault,* c. 1509–10. Fresco. Rome, Santa Maria del Popolo, Choir.

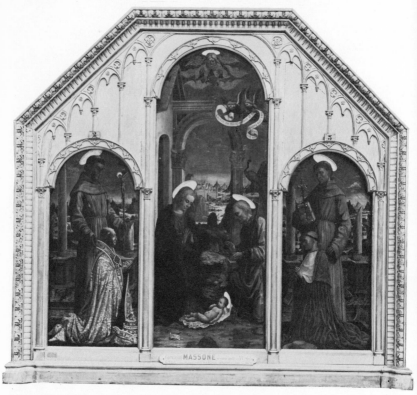

MASSONE

38. Giovanni Mazone, *Holy Family with SS. Francis and Anthony of Padua and Donors Pope Sixtus IV and Cardinal Giuliano della Rovere,* before 1484. From the Chapel of Sixtus in the Cathedral of Savona. Paris, Louvre.

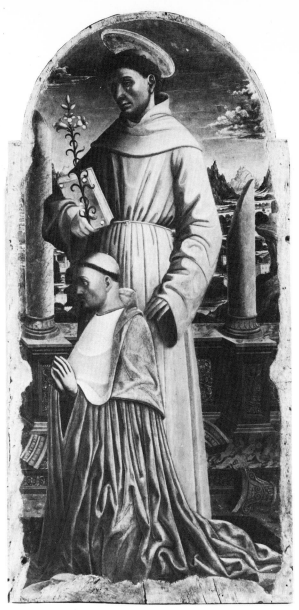

39. Mazone, *Holy Family* (detail with Cardinal
Guiliano della Rovere).

40. Vicenzo Foppa, *Virgin and Child with Donor
Cardinal Giuliano della Rovere*, 1490. From
the high altar of the cathedral at Savona.
Savona, Oratory of S. Maria di Castello.